NATIVE GENIUS

THE PERILS OF BEING AN AMERICAN INDIAN ARTIST

NATIVE GENIUS

THE PERILS OF BEING AN AMERICAN INDIAN ARTIST

RICHARD POLSKY

© 2024 by RICHARD POLSKY
All Rights Reserved
No part of this book may be reproduced in any form or by any electronic or mechanical means including information storage and retrieval systems without permission in writing from the publisher, except by a reviewer who may quote brief passages in a review.

Sunstone books may be purchased for educational, business, or sales promotional use. For information please write: Special Markets Department, Sunstone Press, P.O. Box 2321, Santa Fe, New Mexico 87504-2321.
Printed on acid-free paper
∞
eBook: 978-1-61139-758-1

Library of Congress Cataloging-in-Publication Data

Names: Polsky, Richard, author.
Title: Native genius : the perils of being an American Indian artist / Richard Polsky.
Description: Santa Fe : Sunstone Press, [2024] | Summary: "Native Genius is a non-fiction book which explores the work and lives of contemporary American Indian artists of the American Southwest"-- Provided by publisher.
Identifiers: LCCN 2024046880 | ISBN 9781632936882 (paperback) | ISBN 9781611397581 (epub)
Subjects: LCSH: Indian art--Southwest, New. | Indian artists--United States. | Art and society--United States--History--20th century. | Art and society--United States--History--21st century.
Classification: LCC N6538.A4 P65 2024 | DDC 709.2/397079--dc23/eng/20241016
LC record available at https://lccn.loc.gov/2024046880

WWW.SUNSTONEPRESS.COM
SUNSTONE PRESS / POST OFFICE BOX 2321 / SANTA FE, NM 87504-2321 /USA
(505) 988-4418

For Kimberly Barroso Belanga

"Sorry, I can't get together. I have 'landscape duty' today."
—Tony Abeyta, artist

ACKNOWLEDGEMENTS

I wish to thank the following individuals for their cooperation and support: Doug Magnus, Juan Hamilton, Bill Malone, Tony Abeyta, Baje Whitethorne Sr., Diego Romero, Cara Romero, Joshua Baer, Billy Schenck, Rebecca "Bunny" Carter, Marvin Slim, Randy Rodriguez, Forrest Fenn, Aaron Anderson, Kevin Red Star, Stanley Natchez, Frank Buffalo Hyde, Nocona Burgess, Bennard Dallasvuyaoma, Phillip Reyna, Spencer Tomkins, Linda Durham, Romona Scholder, and Richard Matteucci and Nedra Matteucci.

A shout out to my friends who have always been supportive: Bill and Denise Kane, Matthew and Pheme Geyer, Jonathan Marshall and Lorrie Goldin, Bruce Sherman and Debra Light, Ted and Roz Friedman, and Bruce and Danielle Kretch.

I wish to acknowledge my agent Bonnie Nadell of Hill Nadell Literary Agency in Los Angeles. I would like to thank my mother, Marlit Polsky, author of *America at Last*. And of course, I know that my grandkids, Colin De Arcos and Ennis De Arcos, would enjoy seeing their names in print. Finally, Kimberly Belanga, my green-eyed partner in crimes big and small, to whom this book is dedicated.

CONTENTS

Introduction ■ 11

1 ■ The Enigma of Fritz Scholder ■ 13

2 ■ Lone Dog and NoiseCat ■ 21

3 ■ Indian Golf ■ 27

4 ■ The Giveaway ■ 35

5 ■ The Last Navajo ■ 43

6 ■ Big in Japan ■ 49

7 ■ Marvin Slim ■ 55

8 ■ Roots ■ 59

9 ■ The Last Western Pop Artist ■ 65

10 ■ Mile-Long Hot Dog ■ 73

11 ■ Georgia on My Mind ■ 79

12 ■ Rez Dogs ■ 87

13 ■ R.C. Gorman's Model ■ 95

14 ■ Mercury Dimes ■ 101

15 ■ Albuquerque and Cleveland ■ 107

16 ■ The Fetish King ■ 113

17 ■ Gallup ■ 121

18 ■ A Good Kachina ■ 125

19 ■ The Last Indian Market ■ 133

20 ■ An American Indian Art Renaissance ■ 139

Afterword ■ 143

Sources ■ 145

INTRODUCTION

I arrived in Santa Fe filled with curiosity about the current state of Native American art. My observations caught me by surprise. Native artists were trapped in a conundrum. If they painted stereotypical Native American imagery—Yei gods, buffalo hunts, and kachinas—they were afforded gallery representation. But the minute they deviated from the program, and painted whatever inspired them, galleries and collectors shunned their art. I wondered why they were never extended the same privileges as their Anglo counterparts who were free to paint the subject matter of their choice.

Taking it a step further, I was curious about how important it was to Indian artists to achieve mainstream success in the "serious" New York art world. I always assumed Native painters wanted the same thing as their Anglo colleagues. The question was whether they were they willing to play the career game? On another level, did they see themselves as artists or American Indian artists?

This book is a reflection on spending time in Santa Fe and the surrounding region. It was largely written over a one-year period during the mid-2010s—with more current material added later in the story. One of the highlights was getting to know the painter Tony Abeyta. As Tony's recognition increased, he began to confront the problems that befall all successful artists—whether Native or Anglo. In many ways, Tony's journey mimicked that of his fellow American Indian artists who were trying to stay true to their culture, while straddling the challenges of the Anglo-dominated contemporary art world.

Native Genius is written from an Anglo's perspective. It focuses on indigenous art, but also includes other experiences I've had in New Mexico—which hopefully add flavor and context to the narrative. I've spent a lot of time looking at Native art in the Southwest, hanging out with the artists, and collecting their work. Yet, my observations would obviously be different than a Native American writer's observations. Though it doesn't make them any less valid, it does make them different.

1

THE ENIGMA OF FRITZ SCHOLDER

Fritz Scholder's ghost hovered over Tony Abeyta as he organized the work in his studio for a rapidly approaching show. His second-floor atelier is located above James Reid Ltd, just off Santa Fe's historic Plaza. It is a space filled with the sort of ironies that the art world is famous for. In this case, I am referring to a yellowing exhibition poster from the late 1970s, thumbtacked to the wall, which advertised a Fritz Scholder exhibition—in this very room. Over the years, Tony had taken on the mantle of Scholder's outsize legacy.

As a young man, Tony was no different than any other American Indian artist, having painted the typical Yei gods and kachina dancers. Though he executed them better than anyone else, they remained what they were; high quality decoration. Fortunately, Tony also developed a series of landscape paintings that filtered his personal style through the collective sensibility of the century-old Taos Society of Artists. By breaking up the geometry of Taos's ubiquitous clouds, violent downpours, and Sangre de Cristo Mountains into semi-cubistic forms, he brought their work into modern times. The landscapes felt alive; they were transformed into living, breathing organisms. You wanted to step into them and wander the sage-lined dirt roads, soak in the ambiance of the old adobes, and feel the sting of the rainstorms.

The next evening, Tony walked across the Santa Fe Plaza to the Owings Gallery on Marcy Street to attend his opening reception. The gallery's long narrow interior and highly polished wood floors resembled the lanes of a bowling alley. The intensity of the lighting reminded you of the tall standing racks of lights that highway crews employ when doing nighttime road repairs. That evening, the gallery was packed with revelers, collectors, and friends. The walls were ringed by Tony's trademark

landscapes, two pictures of swooping black and white magpies, and the show's dramatic centerpiece—an eight-foot-long painting of the Grand Canyon. The Grand Canyon has been a venerable subject of painters throughout the history of American art. But no one ever painted this uncanny chasm like Tony. The canyon's variegated mauve and mocha strata brought back vivid memories for all those who have visited the natural wonder. The painting's hypnotic space drew you in and wouldn't let go. In weeks to come, the Smithsonian would buy the picture for its permanent collection, paying sixty-five thousand dollars for the privilege—a record price for one of Tony's paintings.

As a veteran of gallery openings, Tony knew enough to arrive fashionably late. He breezed in to the Owings Gallery, resplendent in a well-tailored black suit. He exuded confidence. He sported a crisp short haircut, his straight black hair flecked with gray. His shoes were Prada. He wore oversized designer eyewear. A tiny bear claw tattoo was visible on his left hand. With his handsome features, talent, and keen intelligence, you only had to take one look at him to know the gods had touched him.

Audiences are used to seeing Native American painters who typically show up for their openings wearing a black leather vest and a bolo tie. Often, their long hair is braided or tied back in a ponytail. The logic seems to be that if you're an American Indian painter, you'd better look the part. But that evening at the Owings Gallery, as Tony Abeyta's admirers gathered around, he made a different kind of a statement. It was as if he was saying, I happen to be an American Indian who makes paintings—not an American Indian painter. It was a moment that Fritz Scholder would have relished.

§

Despite a range of personal demons, Fritz Scholder managed to forge a career that transcended Native American art. Some people prefer the work of T.C. Cannon. But in terms of Scholder's influence on other American Indian artists—the fact that he transformed the entire direction of Native American painting, the number of museum collections that

he's included in, his brief penetration of the New York art world, and the strength of his resale market—he towers over them all.

Fritz Scholder's journey to stardom can only be described as both wonderful and frustrating. Wonderful because he achieved so much. Frustrating because he could have achieved so much more. Scholder was held back by a gnawing insecurity over his identity and the very nature of his being. He was conflicted over whether he was an artist or an American Indian artist. For that matter, he wasn't sure he was an American Indian, since he was only one-quarter Luiseno.

Regardless, Scholder's art career was on the fast track from day one. He was fortunate enough to have studied under the painter Wayne Thiebaud at Sacramento City College. Thiebaud, who was also a gifted instructor, taught Scholder how to apply paint in a lavish expressionistic manner. Thiebaud also convinced his prize student to subscribe to his philosophy of making art: "You can paint whatever you want as long as it's good." This was solid but terrifying advice; it opened up the entire visual world and its myriad of options.

Scholder's other major early influence was the British master Francis Bacon. Scholder visited the Tate in London and was mesmerized by Bacon's powerful take on the human condition. In particular, Scholder absorbed how the contorted facial expressions that Bacon painted conveyed a sense of inner torment. This lesson in emotional intensity would come in handy when he turned his attention to recounting the historic massacres of Native people. But that's getting ahead of the story.

Scholder's earliest mature works were abstractions of the New Mexican landscape. He used deft brushstrokes and a rich palette to capture the essence of the region's spectacular rock formations, depicting them as layer cakes. The paintings were attractive, but could hardly be described as innovative. It wasn't until Scholder became an art instructor that things really got rolling. During the mid-1960s, he was invited to teach at the newly formed Institute of American Indian Arts in Santa Fe. The "IAIA," as it is commonly known, was an art school that was ahead of its times, which has managed to remain relevant to this day. Led by a cutting-edge faculty, students were encouraged to think independently and break away from stereotypical Native imagery. Among the first wave of teachers were

the Chiricahua Apache sculptor Allan Houser, the Hopi jewelry designer Charles Loloma, and Fritz Scholder.

Scholder took a radical approach as a faculty member. He preached to his students that they had no chance of making it in the art world if they painted American Indians. Fortunately, some of his best pupils chose to ignore him, portraying Native Americans in a bold new way. Gone were the chiefs in war bonnets dancing around the campfire. Instead, the IAIA students painted American Indians as they actually lived in today's world. They hung out at bars, paraded around town in cowboy regalia, and ate ice cream cones in front of Baskin-Robbins.

But here is where the story grows (and remains) controversial. Scholder was influenced by his students, rather than the other way around. His paintings resembled theirs. Scholder's American Indians also hung out at bars, wore cowboy clothes, and ate ice cream cones. Despite blatantly ripping off his pupils, he was the only one in a position to parlay their ideas into a career. Scholder was worldly and possessed strong networking skills, which he used to forge connections with art dealers and museum curators. He was a remarkable combination of talent and cunning. His naked ambition recalls a quote attributed to Picasso, "Good artists borrow; great artists steal." Fritz Scholder stole.

During the early 1970s, Scholder was represented in Scottsdale by Elaine Horwitch. Having met her, I can attest that she was a piece of work in her own right. One of the legendary stories about Horwitch was the time she became alarmed by all of the recent burglaries in her gallery's neighborhood. Taking a proactive approach, she spent an entire evening perched on the roof of her space with a loaded shotgun in case the intruders showed. (They didn't). Meanwhile, her charm and aggressive salesmanship led to the sale of an incredible number of Scholder canvases to wealthy Southwestern collectors. The beauty of it all was the buyer could make a timely political statement by hanging a Scholder on their wall (this was the heyday of the American Indian Movement), while decorating their home with a potential investment. Scholder parlayed his regional success to a breakthrough in SoHo, where the Cordier & Ekstrom gallery represented him. Scholder had accomplished the near impossible. For a brief moment, he transcended the stunted Native American art scene and

became part of the mainstream contemporary art world in New York.

Fritz Scholder was now an American Indian rock star. There's a famous black and white photograph of him posed in front of his Rolls Royce convertible, parked in front of a giant saguaro cactus, holding a sleek Afghan hound tugging on a leash. He also owned an impressive century-old adobe home in Galisteo and a spacious loft in SoHo. Scholder reveled in his newfound status. The honors and accolades poured in. Among them was a prestigious artist-in-residency appointment at Dartmouth College. As both his ego and his bankroll grew, he commissioned Andy Warhol to paint his portrait. It seemed nothing could stop the Scholder juggernaut.

But just as Fritz Scholder was poised to take the next step in his burgeoning career, he came to a fork in the road. He knew he could play it safe and continue to paint American Indians, sell out shows, and live a life of luxury. Or he could take a chance and paint what his heart told him to paint. Scholder decided to roll the dice. He had recently returned from a vacation to Egypt and immediately began a series of paintings depicting the Sphinx and the Great Pyramid. A one-person show was mounted at Elaine Horwitch...and nothing sold. In future years, he continued to paint non-American Indian subjects with the same disappointing results. Soon, Scholder left Cordier & Ekstrom to exhibit with the venerable ACA Galleries. But they too failed to generate any interest in the new work. The message was unmistakable; the art market wanted Scholder to continue painting American Indians. The contemporary art window he so masterfully pried open had slammed shut.

In the Anglo-oriented contemporary art world, painters who deviate from their signature images aren't held to the same standards as their American Indian colleagues. Examples of this abound. Scholder's very own mentor, Wayne Thiebaud, built a considerable reputation for his realist paintings of desserts. Though dealers and collectors preferred Wayne Thiebaud to keep painting cakes and pies, he was at least given the benefit of the doubt when his work branched out. Thus, Thiebaud found a receptive audience when he began a series of paintings that exaggerated the vertigo of San Francisco's steep streets. This never would have happened if he was a Native American painter. Let an American Indian artist stray from what's expected of him and his audience moves on.

Collectors are pre-conditioned to buy American Indian art that resembles what they perceive American Indian art to look like. It's an age-old problem whose origins lie with the emergence of the Fred Harvey Company (1878–1965). The hospitality chain was known primarily for providing decent meals and comfortable lodging for East coast passengers traveling by rail to the "newly opened" Western United States. Hoping to add value (and profit) to the experience, the Harvey hotels built American Indian curio shops, which offered Native-crafted rugs, bowls, baskets, and jewelry. For better or worse, the company's buyer frequently dictated to the artisans what their wares should look like. This was especially true with Indian jewelry. Many of the thin silver bracelets were stamped with thunderbirds, arrows, feathers, lightning, rainclouds, and similar "American Indian" symbols because that's what they believed tourists expected. When the American Indians created jewelry for themselves and their families, they used traditional diamond and zigzag motifs. They also made heavier, better quality pieces. To be fair, the Fred Harvey Company handled rare Navajo chief's blankets (their biggest customer was William Randolph Hearst) and other quality textiles. But to this day, tourists who shop for art in Santa Fe still insist on a sense of "Indian-ness" in the work they buy. Paintings had better depict a masked ceremonial dancer shaking a rattle—or else.

It's a delicate balancing act. As someone who collects American Indian art, I admit that I've fallen into the trap of buying paintings of Yeibichei dancers which smack of Indianess. But I also once owned a famous Fritz Scholder painting, *Indian at Gallup Bus Depot*, which depicted an American Indian dressed as a cowboy leaning against an arcade game. The paint-handling was lush, the colors were pure Pop, and the subject matter spoke to the artist's identity crisis over whether he was American Indian or Anglo. Living with this canvas gave me a sense of everything that was right with Native American art. *Indian at Gallup Bus Depot* was a beautifully painted image that could only have been conceived by a Native American—someone who had experienced life in the gateway to the Navajo Nation. What made Scholder such a great artist is that his early work spoke the truth and revealed how American Indians really lived—not how Hollywood portrayed them.

§

After the Owings Gallery opening, Tony Abeyta returned to his studio feeling a sense of satisfaction. But (as the saying goes), there's no rest for the weary. He had recently received a commission from the Heard Museum in Phoenix to paint a permanent mural of the Grand Canyon—even larger than the one acquired by the Smithsonian. Obviously, this was a good problem to have. But for Tony, it was just another one of a seemingly endless chain of commitments that he had to fulfill. As someone on the cusp of turning fifty, he was feeling the pressure of being a successful artist, trying to figure out his next move. Having met Fritz Scholder, he may have asked himself, I wonder if Fritz went through the same thing?

* * *

2

LONE DOG AND NOISECAT

As Tony Abeyta pondered his future, he reflected on his past. He had grown up in Gallup, one of seven children of the Navajo painter Narciso Abeyta, also known as Ha-So-De ("Fiercely Ascending"), and his Irish wife Sylvia Shipley. Though highly talented, Ha-So-De's career never approached his son's success. He had too many family responsibilities which prevented him from making art full-time and realizing his potential. Still, despite a taxing job as an interpreter for the New Mexico Employment Agency, translating Navajo to English for their clients, he managed to leave behind a small legacy of jewel-like paintings. To this day, Tony actively searches for rare examples of his Dad's art that survived.

As a young man, Tony moved to Taos during the 1990s and married a Taos Pueblo Indian named Patricia Michaels, who would go on to future fame on the show *Project Runway*. They also had two children: Margeaux and Gabrielle. While Tony continued to make art, he opened the Shipley Gallery (honoring his mother) in Ranchos de Taos. The gallery flourished during its five-year existence. Tony developed an exhibition program which featured the paintings of the Taos Society of Artists, while continuing to build a market for his own work. He soon branched out and began dealing WPA period New Mexican furniture, traditional New Mexican tinwork, and pictures by the Taos Moderns—the next wave of painters who came after the Taos Society of Artists.

Around 1998, Tony closed the gallery and did something adventurous. He moved his entire family to Venice, Italy, hungry to immerse himself in European culture. His Old World residency lasted three years, coming to an end after "9/11" in 2001. As Tony puts it, "Venice grew hostile." As

a foreigner and a Native American, he found himself constantly hassled when he traveled within Europe. Later that year, he returned to New Mexico and found studio space in Santa Fe. Not long after, Tony and Patricia divorced, but he remained close to his children.

After hearing Tony Abeyta tell me about his personal life, I was curious about how his art itself evolved. He explained that his work is a direct descendent of the American Indian Art Movement of the 1970s. During that decade, Native American painting and sculpture coalesced into a loose group of associated artists, an outgrowth of the Institute of American Indian Art (IAIA), the American Indian Movement (AIM), and the free-spirited post-1960s zeitgeist. Led by Fritz Scholder and T.C. Cannon, Native Americans painted Indian-themed imagery with a go-for-broke attitude. During the 1970s, Scholder and his colleagues' paint-handling grew loose and expressionistic, each brushstroke brimming with emotion. These pictures, which portrayed American Indians immersed in modern life, were more about feeling than an accurate rendering of their subjects; painters left their souls on the canvas. Besides Scholder and Cannon, the key figures of the American Indian Art Movement were Harry Fonseca, James Havard, Allan Houser, Kevin Red Star, Billy Soza Warsoldier, Jaune Quick-to-See Smith, Dan Namingha, Oscar Howe, R. C. Gorman, and Narciso Abeyta.

Besides the new painting that blossomed during the 1970s, there was also a parallel surge of innovative jewelry design, led by the incomparable Hopi artist Charles Loloma. The miracle of Loloma's art was his ability to "paint" with turquoise, red coral, fossil woolly mammoth ivory, and pieces of deep brown ironwood, as if these natural substances were squeezed fresh from the tube. In fact, Loloma's compositions felt more like painting than jewelry. You not only wanted to wear his pieces, you wanted to display them as fine art—which they were. Loloma also mentored a number of female artists, specifically Eveli Sabatie, a wildly innovative non-Native jewelry designer. He also tutored his niece, Verma "Sonwai" Nequatewa, whose work was heavily influenced by him, but quite beautiful in its own way.

Crucial to the American Indian Art Movement was *The Sweet Grass Lives On*, by Jamake Highwater, published in 1980. Oddly enough,

Highwater gave the impression that he was a Cherokee Indian, but he was really an Anglo. The book features the stories and work of fifty Native painters and sculptors, many of whom were receiving national exposure for the first time. Here was indisputable evidence of serious Native artists who "did their own thing" (to quote an expression of the era), exclusive of the New York art scene. Highwater's book was a revelation to a lot of the painters themselves. *The Sweet Grass Lives On* acted as a unifying factor, allowing these artists to realize that they were not alone when it came to redefining Indian art. Though pleased by this burst of recognition, the majority of these painters could have cared less about receiving approval. They played it cool, especially when it came to the greater art world. Their attitude was more "let them come to us."

By the 1990s, demand had faded for the artists of the American Indian Art Movement. Scholder quit painting American Indians, Cannon had long since died in a car accident, and the rest of the painters became less visible. Basically, it came down to a lack of support from Santa Fe's galleries, which had moved on to different work. The movement had been largely dependent on visitors who bought art on their trips to Santa Fe and disseminated it across the country, bringing the artists to the attention of a wider audience. Without representation and shows in Santa Fe, the best days of the American Indian Art Movement were over.

In some ways, the Native American community also shared in the blame. Few American Indians opened galleries of their own to promote their contemporaries. While the town's chamber of commerce loved flaunting the Indian connection, they offered little in the way of support for high-end Native-owned art ventures. During my yearly excursions to Santa Fe, dating back to the late-1980s, I don't recall visiting a single one. It wasn't until I spent an entire year there, that I came upon the short-lived Lone Dog NoiseCat gallery.

Lone Dog NoiseCat was located on Delgado, a side street just off the beginning of Canyon Road. When I first visited, a small black and white mutt trotted out to greet me. I began to pet him when a tall Native American man with long braids came outside. In a weak attempt at levity, I pointed to the critter and asked, "Is this the lone dog?"

"No, I'm the Lone Dog."

It turned out Lone Dog was Todd Bordeaux. He was the co-owner and one of the gallery artists. Lone Dog produced elaborate beadwork. His objects were composed of hundreds of colorful tiny glass beads and often depicted scenes from the natural world. A large belt buckle, beaded with a gorgeous green luna moth, was prominently displayed in a glass case.

A moment later, Lone Dog pointed to his partner in the operation and said, "I'd like you to meet NoiseCat."

NoiseCat, whose full name was Ed Archie NoiseCat, was impressive. He was tall, with straight black hair down to his waist, an athletic build, and a no-nonsense demeanor. Originally from the Pacific Northwest, NoiseCat was a first-rate sculptor, who carved wild creatures in wood or cast them in glass. Especially effective was a group of life-size glass salmon, clustered on a ledge as if they were swimming upstream.

Sensing he wasn't someone to be messed with, I walked around the gallery, carefully looking at the art while trying to think of something complimentary to say. The work wasn't the usual stereotypical American Indian imagery that you saw around town. Besides featuring some younger artists tuned in to the gritty urban environment, the gallery also paid homage to their elders, including Billy Soza Warsoldier. I saw a painting of his depicting a wolf with his fangs barred, thickly painted in hot reds and yellows. It was the first time I had seen his work in person.

Pointing to it, I said to the two proprietors, "That's a strong painting. I like the way the intensity of the brushstrokes reinforce the wolf's fierce demeanor." I was pleased with myself. I managed to say something positive while also sounding authoritative.

NoiseCat broke in, "You act surprised that we have good work here. What did you expect to find? Paintings of fucking Indian maidens down by the stream?"

Fortunately, Lone Dog came to my rescue, breaking the tension with laughter. Still, I could tell my presence wasn't particularly appreciated. I sensed the gallery coveted the Anglos' dollars, but they weren't willing to "play the role" in order to make sales. While I thought NoiseCat was a difficult personality, I respected his stance. If the gallery was going to become successful, it was going to be on his terms.

Over the next few months, I would occasionally stop by Lone Dog NoiseCat. Their shows were always provocative. Probably the best work I saw was by the Flagstaff-based Navajo painter Baje Whitethorne Sr. I was stunned by the power and beauty of his red rock landscapes. His confident paint-handling, the strength of his draftsmanship, and the sheer vibrancy of his colors were a revelation. But where Baje's work really soared, literally, was with his portrayal of the skies above; clouds to be specific. His clouds are a virtual tightrope walk between form and spirit. The viewer tends to lose himself in their structure. You want to climb into them, curious about what's inside. They are at once anthropomorphic, shapeshifting before your eyes. But they are also edgy, displaying a slight degree of menace like a gathering storm.

Eventually, I managed to reach a state of détente with NoiseCat. He grudgingly realized my interest in both his work and the gallery's progress was sincere. I began to feel more welcome. Unfortunately, the space never made it through its first year of operation. I'm not sure what happened, but one day I stopped by and the building was empty. Even the outdoor signage—which made reference to how bounties were once offered for killing American Indians—had been stripped away. Still, their pinnacle of success remains.

As for the American Indian Art Movement, most of the painters have passed on. But one of the remaining key figures, Kevin Red Star, continues to make strong work. Given the current penchant for institutions to re-evaluate art history, and be more inclusive, you'd like to believe a prominent art museum will someday mount a major show about the movement. This would likely trigger corresponding shows of the individual artists at various galleries.

Before I had learned about the American Indian Art Movement from Tony Abeyta, I had no idea that there were probably two-dozen significant Indian painters and sculptors in the Southwest—who made art concurrently with Andy Warhol, Robert Rauschenberg, and Jasper Johns—that was every bit as valid. As Tony was quick to point out, the Native artists from the 1970s provided a springboard for him, and made his career possible. And he was only too happy to share his gratitude with me.

...

3

INDIAN GOLF

I ran into Diego Romero at Counter Culture, a hip neighborhood cafe, just down the block from the renovated adobe I lived in on Baca Street. He greeted me warmly, "Richard! Good to see you. When did you get into town?"

"I just arrived, man," I grinned. "I heard you got married."

"Not only did I get married, but we just had a kid—named Paris," announced Diego, beaming with pride.

"How's Cara?" I asked, referring to his new wife.

"She's great. You've really got to take a look at her work. There's a terrific piece down at Robert Nichols that won a first-place ribbon in photography at last year's Indian Market."

I was already familiar with Cara Romero's photographs. Her Native American parody of the famous Annie Leibovitz *Rolling Stone* cover photo of a nude John Lennon, curled up with Yoko Ono, was fast becoming a Santa Fe icon. Cara's version mimicked Leibovitz's pose, only it featured a semi-naked man wearing a real buffalo head, cuddling a Native American woman. When I viewed the large format picture for the first time, I pretty much wrote it off as being merely clever. Yet, the image stayed with me.

"Have you seen Tony lately?" asked Diego.

"Yeah, we've been hanging out quite a bit since I got into town."

I had originally met Tony Abeyta through Diego Romero. Though they're friends, they treat each other like brothers. They share a history that stretches back to the days when they were roommates at the IAIA. However, their personalities couldn't be more different. Where the two artists intersect is with their fierce desire to create work that will survive the test of time.

Diego grew up in Berkeley in a well-educated family. His mother is Anglo, his father is a Cochiti Indian. As a youngster, he was a typical kid who enjoyed sports and liked to read comic books. At an early age, he began to draw his favorite superheroes, displaying a precocious sense of draftsmanship. As his natural artistic ability continued to develop, Diego decided to pursue a career in art. He attended the Institute of American Indian Arts in Santa Fe for one year, then moved on to Otis Parsons School of Design in Los Angeles, where he earned his BFA. During the 1990s, Diego found himself in the graduate program at UCLA, studying under the well-regarded ceramicist Adrian Saxe.

From day one, there was a clash of wills between student and teacher. According to Saxe, an object wasn't a work of art unless it was grounded in some form of intellectual bedrock. Though it was obvious to Saxe that Diego had the technical chops, he felt he was intellectually lazy. Worse, Saxe accused him of making "Santa Fe" art. It got to a point where he told Diego if he didn't step it up a notch, he could forget about seeing his master's degree.

Something clicked. Diego dug deeply into his Native American heritage and discovered the wondrous pottery of the ancient Mimbres people, who flourished one thousand years ago in the southwestern corner of New Mexico. The centers of their bowls are decorated with pictorials of stylized human figures and indigenous creatures, such as hares, tortoises, and caterpillars, framed by rims with tight geometric patterns. Diego's breakthrough was to appropriate the Mimbres format and substitute images lifted from modern life, filtered through an ironic Native American perspective.

One of his finest bowls depicts the incongruity of a male American Indian on a golf course trying to play a white man's game. As Diego explained to me, "I like to chronicle the absurdity of human nature and there's nothing more absurd than an Indian playing golf." He continued, "Most pueblo pottery—the historic stuff and even the contemporary work—addresses a dialogue with fertility, rain, growth, and animals associated with that. My dialogue centers around post-industrialization, the commodification of Indian land, water, alcoholism…" It's this dichotomy of retaining his American Indian roots, while being an artist very much of his times, that gives Diego's work its edge.

As Diego and I got to know each other, he shared with me that he had begun training for an upcoming Corn Dance at the Cochiti Pueblo. He insisted I come watch the annual event and even invited me to a feast, following the dance, at his uncle Zero's house. I quickly accepted his invitation, recalling what the Santa Fe artist Doug Magnus once told me: "The key to understanding the mysteries of the region can be found in the Indian dances."

One hundred years ago, people would journey to the Taos Pueblo to observe a Buffalo Dance, the San Ildefonso Pueblo to view a Deer Dance, or the Hopi Pueblo to see a Snake Dance. Unfortunately, many visitors were disrespectful. They took photographs, talked loudly, pointed at the participants, and even tried to sneak into the sacred kivas—which have always been off limits. Guests failed to appreciate that these were religious ceremonies, not Disneyland. As someone who's Jewish, I know I would resent anyone who walked into a temple and elbowed his friend, "Look there's a Torah! Let's get a photo."

These days, only a limited number of dances are open to the public and all of them are subject to restrictions. From the moment you enter the reservation, you are given fair warning that you are not allowed to takes pictures, utilize any sort of recording device, or even make sketches. All of the rules are enforced by the tribal police. And make no mistake, they will confiscate your camera—and not return it.

By the time I arrived at the Cochiti Pueblo to watch Diego participate in the Corn Dance, it was already in progress. Smoke drifted over the dirt plaza from a distant forest fire in Los Alamos. The light was hazy, creating a spooky atmosphere. Perhaps two hundred participants, ranging from young children to grown men and women, began to snake through the dirt, propelled by a lone drummer and a circle of chanting elders. Before long, I locked into the hypnotic beat and began to gently sway to it. The whole scene felt primeval, like something out of an old Edward Curtis photogravure. The dance seemed to exist simultaneously in the past and the present.

I was mesmerized by the sheer pageantry of it all. The women were costumed in long black dresses, tablitas, moccasins, sashes with bells tied on, and necklaces of turquoise or orange spiny oyster. The men were

stripped to the waist and smeared with clay colored with a blue pigment. A few parrot feathers protruded from their heads. They were also adorned with necklaces and bells and sported a small evergreen tree branch tucked under each armband and ankle band. The children who participated wore the same clothes as the adults, keeping the tradition alive for the next generation.

I spotted Diego. At fifty, he might have been the oldest dancer out there. Sweat poured off his body as he labored to keep his dancing strong. He had morphed from a contemporary artist into a mystical warrior. The transformation was remarkable. Diego once told me that when he moved from Berkeley to Santa Fe, the Cochiti people were slow to accept him. They viewed him as an outsider who was expected to prove his worthiness. He did so through hours of hard practice, learning the dances and their symbolic meaning. Today's performance left little doubt about his commitment to the tribe.

After the dance ended (it tends to run off and on all day), I found an exhausted Diego, slumped against an adobe wall.

"Diego, you were great!" I said.

"Hey, Richard. Thanks for coming," was all he could muster.

Just then, his ex-wife showed up with his daughter Cricket. After some small talk, Diego managed to get to his feet and take Cricket's hand, in search of a snack.

Diego turned to me, "Oh, I forgot. My uncle Zero lives about a mile from the plaza. I've got to run, but see if you can catch a ride with someone."

Before I could say anything, he was off. I scanned the plaza and saw everyone scatter in different directions. It was feast time. I approached a total stranger and said, hesitantly, "You wouldn't happen to know Zero Romero, would you?"

The young man laughed and gave me one of those "get with the program" looks, "Of course I do—everyone in the tribe knows everyone else."

"Any chance of negotiating a ride to his home? I'm a guest of Diego Romero."

"Sure, I'll take you."

We wound up in a parking lot, where my new friend quickly spotted his vehicle. Its badly dented and rusted brown exterior, cracked windshield, and punched out headlights, reminded me of Filbert's car "Protector" in the Indie film drama *Powwow Highway*. I climbed in and reached for my seatbelt—only there wasn't one. It's only a mile, I thought. Within five minutes, we arrived at the residence of Zero Romero. I was greeted by Diego's son Santiago. Like his father, "Santi" was a ceramics artist. He had recently returned from studying art on a full-scholarship to Dartmouth.

"Polsky—you made it!" he cried.

Zero's home was a modest cement block bungalow. It was crammed with several dozen revelers drinking beer or Pepsi while enjoying a spread of edibles. Moments later, Diego showed up. He was embraced warmly by his cousins and other relatives. Despite his worldly success—Diego had recently returned from a show of his work at the Louvre—he was seen as just another member of the tribe. Indians are less competitive than their Anglo counterparts. The "American Indian way" was not to call attention to the individual. It was all about what was best for the tribe.

A week after the Corn Dance, I stopped by Diego's house, located in a residential section of Santa Fe. He had converted one of the rooms into a studio and installed a kiln in the backyard. I began looking through Diego's sketchbooks. The pen and ink illustrations reminded me of the best imagery found in graphic novels. Diego's line was "knowing." There was no excess and no wasted motion. Everything was crisp and purposeful. A drawing of a Corn Dance depicted a female dancer in the foreground, surrounded by a young audience watching from the pueblo rooftops. A few of the teenage boys wore football jerseys emblazoned with skulls. Their female counterparts were outfitted in hip-hugger jeans and tight-fitting tops, accentuating their curves. The ceremony may have been traditional but the actual scene spoke of today.

I said to Diego, "This is a great drawing. Would you consider using it in a bowl if I commissioned you?"

"Sure, Richard." Then he added, with a smile, "If you can pay for it in advance I promise you'll get more than your money's worth."

Now here was a dilemma. Typically when you commission a work from an artist, you give him half of the money up front, and the other half

upon its completion. Diego was asking me to take a leap of faith. On the other hand, having just witnessed an actual Corn Dance only added to my desire to own a bowl that commemorated the experience. I reached for my wallet and wrote him a check.

Happily, in about six months I received the vessel and was overwhelmed by its beauty. I got on the phone with Diego and immediately commissioned another smaller ceramic work. This time, he made me a bowl with a central image of a Native American couple posed as tourists, holding a guidebook, while shopping for jewelry under the portal of the Palace of the Governors. A larger version of this work is often on display at the New Mexico Museum of Art.

Once again, Diego came through, creating a small masterpiece. But here's where the story takes a twist. Tony Abeyta had recently mentioned to me that he owned a bowl by Diego that his housekeeper had accidentally knocked off the shelf and broke while dusting it. I quickly proposed a trade to Tony; the Diego Romero "tourist scene" bowl for one of his New Mexican landscape paintings. Tony agreed to the swap with the caveat that he had a number of obligations to fulfil before he could get started on my painting. With the intention of locking up a commitment, I shipped him the piece and hoped for the best.

Months passed. Occasionally, I'd give Tony a call to check in with him. I didn't want to push him too much, less I receive an inferior painting because he rushed it. But I also wanted him to be aware of how much I was looking forward to living with one of his pictures. A few more months passed with no word from Tony. Finally, when I emailed him that I'd be in Santa Fe shortly, I heard the magic words, "Give me until the end of this week and when you stop by the studio your painting will be ready."

When I arrived at Tony's place, I found him literally putting the finishing touches on my painting. He stepped back from the easel to reveal one of his signature landscapes. Its pictorial tension was derived from a tug of war between an impossibly beautiful group of cerulean and turquoise-colored clouds, broken up into angular forms, and a foreground chock full of raw sienna hills anchored by flowering golden chamisa. The painting was a winner.

Tony remarked, "It's still wet so be careful with it. Maybe you can

put it on the floor of your car so nothing touches the surface."

"Sounds like good advice," I said, while reaching for it. The painting was only inches from my hands when Tony stopped me.

"Wait a minute," he said.

Tony studied it intensely. I had no idea why; it looked finished to me. In fact, I almost grabbed it away out of fear he would ruin it. Instead, I watched him pick up one of his brushes, dip it in some canary yellow oil paint, and dab a bit of color onto one of the chamisa's clusters of flowers. It may not have seemed like much, but that small gesture activated the shrub, and in turn the entire painting. Tony had gone the extra mile by reaching into his psyche to summon the one "move" he needed to make to bring the painting to perfection.

4

THE GIVEAWAY

I asked Tony Abeyta, "Didn't you once tell me you met Fritz Scholder?"

Tony nodded, "Sure, I met him a few times when I was much younger—we sat together at a gallery dinner but didn't talk much. I was a lot more interested in how quickly he worked and how he was able to sketch an Indian in the center of the canvas, add a horizon line, and then charge fifteen thousand for it. I wondered how you got to that point as an artist. But Scholder was never an influence on my work."

"Could he finish a painting in an hour?" I asked.

"More like fifteen minutes," laughed Tony. Then he added, "But he was a great artist."

Speaking with Tony made me recall my initial introduction to Scholder's work. I was at Green Apple Books, in San Francisco, when I came upon a used volume of *Fritz Scholder: Indian/Not Indian*, which served as the exhibition catalog to his Smithsonian retrospective. The reproductions and the text—especially the essay by Paul Chaat Smith—led to an emotional connection with the work and the artist's personal struggle to find his place in the art world.

Wanting to know what Fritz Scholder was really like, I contacted the veteran art dealer Linda Durham, who was friendly with his ex-wife Romona. Thanks to Linda's introduction, I was invited to visit the Galisteo home that Romona shared with Fritz for many years. Though Galisteo is somewhat off the beaten path, it (once) counted a number of famous artists among its 265 residents, including Bruce Nauman, Susan Rothenberg, and Agnes Martin. When I arrived at the town of rolling ranchland, only thirty minutes south of Santa Fe, I quickly found Romona's house. It was a magnificent adobe that was over 150 years old, with thirty-six-inch-thick walls, a long portal, and a detached studio.

Walking around her spacious yard, I said to Romona, "You have an amazing house. I especially like your portal."

"It's pronounced por-taal," she explained. "A portal is a space under an archway."

There was so much to learn about the region, including its local idioms of speech, I thought.

Romona poured a couple of peach iced teas and offered me a seat in the living room. Now in her seventies, she was still a beauty, with flowing curly red hair that I recognized from paintings where she modeled for Fritz. She continued to work full-time as a therapist and maintained an office in Santa Fe. As we talked, my eyes did a lap around the room and came upon an imposing stuffed buffalo head, hanging over the fireplace. You forget how immense these creatures are until you see one in person. There was also an array of American Indian artifacts the couple had gathered over the years, including a six-foot long eagle feather war bonnet. Surprisingly, there was only one Fritz Scholder painting on display and an atypical one at that; a close-up of a flower.

I queried Romona, "Isn't that war bonnet illegal to own because of the eagle feathers?"

She nodded, "Yes—for you and me. But Fritz could own it because he was an Indian."

As I continued to study the war bonnet, I said, "I've read a lot about how Fritz was at odds with his identity. How do you think he saw himself?"

"As an Anglo," said Romona without hesitation. "You have to remember he was only one-quarter Indian."

We walked out to his studio. Although I was shown dozens of paintings, there weren't any of real quality; mostly canvases from his questionable production during the 1980s. Scholder had been dead for almost a decade and his estate had already been cherry-picked. Romona slid a large canvas out of the wooden storage racks. It was a portrait of Fritz sitting in a wicker chair, dressed entirely in blue denim, with Romona standing behind him. Both figures radiated joy—an allusion to happier days together. In most of his self-portraits, Fritz was brooding. This was the first one I ever saw where he was smiling. What's more, he looked Anglo. The painting didn't bear a trace of Indianess. It was as if he

had momentarily given himself permission to be who he really thought he was. In all likelihood, this picture never sold because he didn't appear to be Indian enough. However, it clearly demonstrated how much pressure Scholder was under to be seen as an indigenous person, who painted indigenous people, in order to keep his market primed.

Later that week, I got together with Tony Abeyta and told him about my visit with Romona Scholder. He seemed more interested in knowing what remained in Fritz's estate, but wasn't surprised when I mentioned there was little of consequence. Tony then invited me to his home to see his latest acquisitions. I smiled to myself, recalling the last time I had been there.

In retrospect, the story is quite funny. Several years ago, when I hardly knew Tony, I casually mentioned to him that I was thinking of moving to Santa Fe for a year. His ears perked up and he said to me, "You know, I'd like to spend a year in the Bay Area. Maybe we should talk about trading places."

"Sounds like an Eddie Murphy movie," I said, with a laugh.

Tony rolled his eyes.

Then I got serious. "Hmm, that could be interesting. What does your home look like?"

"Well, it's a double-wide trailer, only ten minutes from the Plaza. Why don't we take a drive so you can see it."

Tony locked up his studio. We walked along Palace Avenue and came to a late model silver Porsche Carerra. "Get in," was all he said. I thought we had the wrong car. Then, I looked down at his feet and noticed he was wearing a six hundred fifty dollar pair of Pradas. Again, I was mystified. As I slid into the leather bucket seat, I thought, *This isn't adding up.*

We took a short drive down Old Santa Fe Trail, past a string of upscale homes. Tony eased his Porsche along a washboard dirt road to the steady beat of thumping tires. Soon, we came to a tremendous modern adobe dwelling.

"You live here?" I asked incredulously, while thinking, *Some double-wide.*

Tony grinned, "That's right."

I could only shake my head. As we entered Tony's house, I was

stunned not only by its scale but by the scope of his art collection. The walls were covered with paintings by his friends along with an early yellow Fritz Scholder, shaped like a shield, and illustrated with a lone Coors beer can. It made me think of Scholder's most famous painting, *Indian With Beer Can*, owned by Ralph Lauren. There was also a smattering of ceramics and American Indian artifacts. Finally, I saw several small-scale, but highly desirable, Agnes Martin canvases. Tony once told me that when he lived in Taos, he developed a relationship with the esteemed Minimalist painter. He spoke fondly of having lunch with her once a month, as well as how he'd occasionally chauffer her around town.

I turned to Tony, "This is really impressive. But I'm not sure it would be a fair swap for my rental in Sausalito. I mean, it's nice—with a great view of the water—but it's only about one-fifth the size of this place."

He nodded, "I understand—it was just a thought."

That day, as we finished up our conversation, I asked Tony whether there was a Santa Fe gallery which currently represented Fritz Scholder. He explained that although a number of dealers had access to paintings from the estate, which had been divided between his two ex-wives; no one had an exclusive. I sensed this was part of the reason why his work remained undervalued. An artist of his stature needed a gallery which served as an official representative. This was necessary to maintain a meaningful price structure, serve as a clearinghouse for information, and promote the work to expand the artist's legacy.

I said to Tony, "It's too bad Lone Dog NoiseCat closed. They might have been an interesting choice to handle Fritz's work."

Tony shrugged, "Hey, if you're interested in other Native-owned galleries, you might want to meet Stan Natchez. But he only shows his own work."

"Tell me about him."

"Stan's a friend of mine who has a space just off the Plaza. There's a large painting of his always hanging in the window—it's covered with dollar bills and has an Indian chief painted on it. You've probably walked by it a hundred times—you can't miss it."

"Oh, yeah. Isn't that the place where there's a big sign that says 'No Photography?'"

"That's it."

"Do you think we could walk over there? Maybe you could introduce me to Stanley?"

Tony looked down at his watch, "Okay, but then I've got to get going."

We drove back into town. As we approached the Stanley Natchez Gallery, the artist was standing out front.

"Tony, good to see you," said Stanley. "Who's your friend?"

"This is Richard Polsky—he's a good buddy of mine."

I shook hands with Stanley and he invited us in. Once inside, I noticed a stack of 9" x 12" canvases. Each depicted the Kiowa chief "Two Hatchets," whose likeness was photo-silkscreened (ala Andy Warhol) onto every canvas. Natchez was planning to distribute them as gifts to fifty lucky individuals. He announced to me, "There are a lot of people out there who can't afford one of my paintings, so I'm going to give them one." The plan was to give something back to the Santa Fe art community, which has allowed Natchez to live completely off the sale of his work for the last twenty years.

Stanley Natchez originally arrived in Santa Fe during the late 1980s to attend the opening of his show at Elaine Horwitch's Santa Fe outpost. It was his first exhibition after earning his undergraduate degree from USC and his master's from Arizona State. When Natchez arrived at the gallery, he looked around and noticed some of the walls were hung with Warhols and Scholders. He was nervous about whether his work would hold its own with Pop and Native art royalty. He also wondered, like all newly-minted art school graduates, if he'd be able to support himself from his art. Fortunately, his work sold from the get-go.

Part of his early success can be attributed to how he used a cornucopia of less-traditional materials, including beadwork, gold leaf, maps, old pages from *Harper's*, and even puzzle parts. By incorporating these objects, his intention was to bring the real world into his art. Encouraged by strong sales, Natchez began a new series by mounting a sheet of thirty-two uncut dollar bills onto a canvas and painting a traditional buffalo hunt scene on it. As he put it, "I knew I had found something that hadn't been done." He had come up with a way to honor his forefathers, while staying current.

Natchez, who's Shoshone-Tataviam, continued to explain, "We had our own style of doing art that wasn't accepted until much later. The first American Indian paintings were done on buffalo hides during the eighteen eighties and eighteen nineties. The sheet of money is a modern-day buffalo hide. After doing my first money paintings, I bought two thousand dollars worth of currency from the Bureau of Engraving and Printing in Washington DC and began a series of images depicting Native chiefs and warriors, including Medicine Crow, Ten Bears, and Two Hatchets." Natchez felt the work resonated with irony as these long-ago tribal leaders confronted the likeness (on dollar bills) of the early Anglo leader George Washington.

Next, Natchez began overlaying "ledger" drawings on currency. During the late nineteenth century, when various Plains Indian tribes were incarcerated, they were occasionally given ledger accounting books, along with pencils, ink, and watercolors by their White captors. They drew images from memory on their lined pages, including battles, buffalo hunts, and courting scenes. Though now collectible, these works on paper are controversial because they were done under duress while the artists were prisoners. Natchez chose to tap into the emotional past in a painting appropriately titled, "Capture the Flag." Here, on a ground of newly created ledger drawings, he illustrated a lone Indian on horseback carrying an American flag, while being shot at by government troops.

Before becoming a full-time artist, Natchez pursued other interests, including a stint as an editorial advisor for *Native Peoples* magazine. He also taught school. Though Natchez enjoyed the experience, he found himself increasingly drawn to the artistic life. He eventually rented two storefronts on East Palace Avenue in Santa Fe. One building serves as his personal gallery and the other houses his studio. The main room is hung salon style with a diverse group of works, many with repetitive photo-silkscreened images, which reveal the influence of Andy Warhol. Natchez is proud of the connection, feeling he accomplished his goal of being able to "take Warhol and do something else with it." What's tricky is Warhol is so closely identified with the photo-silkscreen technique, that he virtually owns it. Then again, during the 1960s, Robert Rauschenberg was encouraged by Warhol to make some silkscreen paintings of his own—which turned out

to be some of the best work he produced in his career. While every artist has his influences, the idea is to borrow from that painter, and then make it into your own. Stanley Natchez attempted to pay homage to Warhol, while adding splatters of paint to his portraits of Two Hatchets, to make them into his own.

A week later, I returned on a Friday evening to the Stanley Natchez Gallery where an opening was underway. Stan made an announcement, "We're having a giveaway tonight and we're just waiting for our singers to arrive so they can perform a giveaway song."

Ten minutes later, there was still no sign of the singers. Natchez said, with a grin, "They must be running on Indian time." Finally, three young men from the Jemez Pueblo walked in. They formed a semi-circle and began chanting and drumming while Natchez distributed blue plastic bags, each containing a small canvas. Paintings were given to collectors, supporters, and friends. Though every picture was screened with Two Hatchets's likeness, no two were alike because the background color varied. They were intentionally placed in opaque bags so there was no favoritism over who got the "best one." Mine had a peach-colored background.

The room buzzed with delighted fans, thrilled to add a new Natchez to their collection. They approached the artist to thank him for his act of generosity. I could tell he savored the interaction. I overheard him say to someone, "My art is about you and the way I respond to you. That is my experience."

•••

5

THE LAST NAVAJO

Many people have asked about the proliferation of American Indian-owned casinos in the Santa Fe area and why almost none of them display serious American Indian art. It's a good question. However, there is one casino that intentionally earmarked a substantial amount of cash to acquire a quality collection of contemporary Native American art: Buffalo Thunder. Under the guidance of the artist George Rivera, the casino managed to put together an outstanding group of roughly 400 works, representing every Native tribe in New Mexico.

All of the "local favorites" are here: Frank Buffalo Hyde, Diego Romero, Mateo Romero (Diego's younger brother), Roxanne Swentzel, Tammy Garcia, Dan Namingha, and of course Tony Abeyta. Not only are a number of Tony's landscapes and traditional Yei god paintings on display, but there's also an impressive concho belt that he designed, hanging in one of the wall-mounted display cases. Tony explained, "When George Rivera was putting together the art for Buffalo Thunder, he visited my studio with the intention of buying a few paintings. Just as I was putting the finishing touches on the first concho belt I ever made, he saw it and said, 'I'll take it.' I don't think he even asked about the price."

When I visited the casino, located twenty minutes from Santa Fe in Pojoaque, I wandered around the hotel's second floor lobby, far away from the din of slot machines and the omnipresent cigarette smoke. The large open rooms, where the majority of the art was displayed, had the ambiance of a museum. The ceramics were professionally installed in giant clear acrylic multi-level display cases. The paintings were hung with a generous amount of space around them so they breathed. However, after spending forty-five minutes there, I made a disappointing observation;

I was the only one looking at the art. I sensed there was absolutely zero interest. People were there to gamble, not to study Native American painting. It was a shame because everything Rivera selected represented the acme of each artist's work. If someone wanted a primer on the state of Northern New Mexico American Indian art, all he had to do was visit Buffalo Thunder. In fact, much of the work on view was better than what you'd find by the same artists at the New Mexico Museum of Art.

§

Later that week, I made plans to meet the art dealer Joshua Baer at Downtown Subscription, Santa Fe's most convivial cafe. Curiously, they're not located downtown, nor do they sell subscriptions to anything. The cafe can be found on the affluent East side, where it straddles the large adobe homes that interior design magazines can't get enough of. The "Down Sub," as the locals affectionately call it, serves as both a place to catch up with your neighbors, as well as an office for creative types. During the summer, its backyard is a veritable oasis where you can indulge in an iced coffee and a good book, as fluttering sphinx moths sip nectar from the surrounding chamisa.

The cafe is also known for its occasional celebrity appearance. Ali MacGraw, who lives in neighboring Tesuque, is a regular. Though (then) in her seventies, I was stunned by how good she looked; her cheekbones are still amazing. She also comes across as quite accessible, as evidenced by the number of people who stopped by her table to say hello. The playwright and actor Sam Shepard, grizzled but still handsome, occasionally puts in an appearance. However, he seemed more private; the café patrons give him his space.

When I got in my car, I recalled how during the 1980s, Joshua was the proprietor of the town's finest classic Indian art gallery: Joshua Baer & Company. He was largely responsible for transforming our perception of early Navajo blankets from musty artifacts to full-blown fine art. His gallery once inhabited the same space that Tony Abeyta's studio now

occupies, adding another layer of Santa Fe art history to that building. On my way to the Down Sub, I made a pit stop at Whole Foods to pick up a few items. While shopping I noticed a woman holding a piece of paper with an image of a Mimbres bowl. *Only in Santa Fe*, I thought. The woman turned out to be Eliza Baer, Josh's wife.

"I can't believe you have a shopping list with a prehistoric pot on it," I said with a smile.

"Oh, that," said Eliza, in her shy way. "It's scratch paper from old appraisals. We like to recycle."

Moments later, I sat down to coffee with her husband. We caught up on some gossip and then the subject turned to food and wine. Besides being a Native American textiles expert, Josh also writes a popular column about wine called "One Bottle," for THE *Magazine*, a local arts journal. As the talk transitioned to Native American art, Josh mentioned our recent lunch with Diego Romero. He said, "You know, as wonderful as Diego's bowls are, his pen and ink drawings might even be better."

I agreed with Josh. We discussed what it would take for him to break through to the greater art market. We hypothesized that an important New York dealer would have to be in Santa Fe on vacation, stumble into a gallery showing Diego's work—followed by a few rounds of green chile-infused martinis—before he had an epiphany.

I speak from experience when it comes to explaining the difficulty of convincing a major player to take a chance on exhibiting a Native American painter. About three years ago, I approached Peter Stremmel, owner of the Stremmel Gallery in Reno, and a partner in the Coeur d'Alene Art Auction (the largest Western art auction in America), with an idea. I proposed to Peter that he contact his colleague Bill Acquavella to see if he would put up the money to quietly acquire twenty early Fritz Scholder paintings, followed by an exhibition at his gallery, and the publication of a catalog to promote the event. Acquavella Galleries, located on Manhattan's Upper East Side, is one of the wealthiest dealers in the world. Sotheby's once came to them for help in acquiring the massive estate of the Pierre Matisse Gallery.

At the time of my proposition, high-quality Scholders could be bought for an average of thirty thousand dollars. So, Acquavella would have

to spend approximately six hundred thousand to purchase twenty canvases. As a gallery that represents the estate of Lucian Freud, whose paintings sell for multiple millions, this number was quite modest. Acquavella also shows Wayne Thiebaud, one of America's most expensive living painters, who as previously mentioned was Scholder's earliest teacher. So there's that connection too. An exhibition at Acquavella would announce to the art world that Fritz Scholder was overlooked and undervalued. More important, it would introduce his work to a far greater audience, as a Pop artist in good standing. Acquavella could easily price the pictures at seventy-five thousand and they'd likely sell-out. For their well-heeled clients, that amounts to only the sales tax on an average gallery purchase.

Peter Stremmel sent Bill Acquavella a coffee table book on Fritz Scholder. He let a week go by and then called him to see what he thought. Bill's response was that it was "an interesting idea"—but not for them. I was crestfallen, believing they truly missed out on an opportunity. The problem wouldn't have been selling the paintings, but having enough material in reserve to benefit from Scholder's sure-to-rise prices. But more relevant to the future of Native American art, it would have paved the way for artists like Diego Romero and Tony Abeyta. The serious New York art world has always operated on a herd mentality. Had Acquavella agreed to exhibit Scholder, one of their rivals probably would have moved quickly to offer Tony Abeyta representation, anxious to cash in a genre of art that hadn't been exploited yet.

After telling this story to Josh Baer, he shrugged and led me outside to the parking lot. "I want to show you something."

I followed him outdoors, and sure enough, we ran into Tony Abeyta. He was now driving a Mini Cooper—which he bought for his young daughter Margeaux.

Tony yelled out, "What are you two knuckleheads up to?"

Ignoring him, Josh opened the trunk of his car and produced a "handful of wool"—a Navajo chief's blanket and a double saddle blanket. He held up the saddle blanket against the café's mocha-colored stucco wall, as the late afternoon sun raked the textile's deep colors. Its bold simplicity of design, with its negative center and zigzag border, was a journey into the sublime. I marveled how such beauty could come from a people who

had experienced near-destruction during the apotheosis of their weaving culture. Josh then asked me to assist him with the chief's blanket, which was much larger. This particular example was a prime "second phase," with horizontal bars of brown, blue, red, and ivory. It was also quite valuable; the asking price was one hundred twenty five thousand dollars.

Tony approached the blanket. He stood back about six feet, transfixed by the intersection of history, beauty, and the weaver's connection to the land. I remembered how Josh had once written that a weaver's wooden comb smells like, "wool, dirt, and rain." Tony gently ran his finger across its textured surface. He looked over at Josh, and said with awesome timing, "I'm probably the last Navajo who will ever touch this blanket."

For days, I thought about Tony's poignant comment. Perhaps it was a line he had been saving for the right moment. Or maybe it was spontaneous. Regardless, he and his fellow Native Americans clearly had a different perspective on American history than Anglos like myself. There was no way to understand what he experienced as a Navajo, let alone a Navajo painter. I thought about what it was like to hang out with Tony, versus spending time with him and a group of his Navajo brothers—when I was the only Anglo in the room. On those occasions, there was a subtle undercurrent that seemed to say, "You might be of us, but you're not one of us."

I began to second-guess my own preconceived notion of how American Indian painters saw their lives as artists. I assumed that they were after what most Anglo artists strived for: New York representation, reviews in top art magazines, sales to leading collectors and museums, and a niche in the art history books. I came to realize that's what I wanted for them. I had been guilty of imposing my own values on their careers, rather than considering what they may have wished for themselves.

I once asked Tony to define his notion of success in the art world, but wound up hearing what I wanted to hear. Had I actually listened, and comprehended what he was saying, I would have discovered that his overriding goal was to continue to evolve as an artist. Tony was satisfied with painting Northern New Mexican landscapes and Native-inspired imagery. He wasn't looking to deviate from these themes; he embraced them. The rest of the "stuff"—his career and his place in art history—

would take care of itself. The key distinction between Indian painters of the Southwest and the rest of America's artists is that they prioritize sticking to their cultural roots over careerism. The art always came first.

6

BIG IN JAPAN

Other than the green chile, the most addictive thing about living in Santa Fe is the Native American jewelry. There's something about wearing a Navajo ring, handcrafted from silver and studded with a turquoise nugget, that captures the essence of the Southwest experience. Simply put, American Indian jewelry feels good on you. But despite its inherent beauty and collectability, people still question whether it should be considered fine art.

Many serious Native painters eventually try their hand at jewelry making. Most of them embrace the challenge of producing traditional designs filtered through their personal artistic sensibility. Some of these artists find such pleasure in jewelry making that they give serious thought to doing it full-time. However, when a painter reaches these crossroads, he usually comes to his senses. He knows if you transition to a jewelry designer, the art market frowns upon this sort of thing, and no longer considers you to be an artist.

Fortunately, the jewelry designer Charles Loloma never had to make that decision; he didn't worry about how he was labeled. After seeing his work, few would argue that he was a true artist. I always felt Loloma would someday be exhibited in galleries that handled the top Native American painters. I believed he would drag the best of his fellow artisans along with him and cross over into fine art. But it hasn't happened. Though there are an amazing number of talented individual jewelry designers with devoted followings, such as Richard and Boyd Tsosie, Cody Sanderson, Michael Kabotie, Perry and Quaid Shorty, McKee Platero, Edison Sandy Smith, Norbert Peshlakai, Larry Golsh, and Darryl Dean Begay, full recognition as fine artists eludes them.

Back in 1990, Artwear Concepts, a small company based in Los Angeles known for commissioning famous artists to design jewelry, sought out Fritz Scholder. They contracted with him to produce a small line of multi-colored enamel bolos and pins. He responded by designing a shaggy buffalo head, a skull derived from the Mexican Day of the Dead, and a falcon based on the ancient Egyptian deity Horus. Predictably, the buffalo sold the best.

Just like their counterparts who acquire Native paintings, jewelry collectors will only buy American Indian jewelry with American Indian motifs. Most also insist that the work be created by Indians, as well. If you're an Anglo craftsman, working within the Native American tradition, you're usually out of luck. Even if your designs are exceptional, and you use the finest natural turquoise, most people won't purchase your work because they think that it's not authentic.

Just ask Brett Bastien, one of Santa Fe's outstanding jewelry craftsmen. You would think he would have instant credibility, as the only Anglo ever to have been admitted to the jewelry program at Santa Fe's prestigious Institute of American Indian Art. Even better, he studied under Charles Loloma. During Brett's thirty years in Santa Fe, he's managed to develop a steady clientele. Ironically, he makes a tidy sum on the side by doing repairs on Loloma's work for the local dealer Marti Struever. Brett's Indian-style jewelry is exceptional. Yet, because he's not an American Indian, most of the Plaza's shops won't touch it. Fortunately, Brett has a sense of humor about his non-Native status. The six foot-three artist hallmarks his pieces "BWB" (Big White Boy). But he's also painfully aware of how things work in Santa Fe. As he succinctly put it, "The Indians have Indian Market, the Spanish have Spanish Market, and the Anglos have flea market."

My developing passion for American Indian jewelry led me to take a look at Tony Abeyta's recent efforts in that medium. I had heard that his turquoise and tufa-cast belt buckles, bracelets, bolos, and rings had caused a sensation at his first Owings Gallery show. Tony is a self-professed "stone junkie," who pays top dollar to acquire the finest cabochons from the classic turquoise mines, including Bisbee, No. 8, and Lone Mountain. As he insists, "A ring is just an excuse for displaying a great stone."

Having only seen one example of Tony's jewelry, at Buffalo Thunder, I decided to stop by his studio to see some more pieces in person. When I arrived, the usual entourage was hanging out, including Jaque Fraqua, a young up-and-coming Navajo painter whose street artist sensibility reminded me of Shepard Fairey (who designed the Obama "Hope" poster). I looked around and noticed a handful of rings scattered on the studio's mid-century coffee table. I began trying them on and soon came upon one with a grainy silver band, and a large piece of green Carico Lake turquoise perched upon it. It retailed for fourteen hundred dollars. Since Tony often admired a modest concho belt that I wore, I proposed a trade. It dated from the 1970s and its old brown leather strap was lined with Standing Liberty half-dollars. The artisan who created the belt made a smart aesthetic decision when he selected the "tails" side of each coin, which depicted a bald eagle, whose feathers are a powerful symbol in Indian culture. I had acquired the belt about a decade ago at the annual Tucson Gem & Mineral Show.

Tony asked me, "What do you think it's worth?"

"If it was at Shiprock (a high-end Santa Fe purveyor of Native American art, textiles, and vintage jewelry) it would be expensive. But for the sake of argument, I would call it eight hundred dollars." The problem was that I was still six hundred dollars short, assuming we were trading retail for retail. To close the gap, I proposed throwing in an Ernest Rangel silver bracelet with a lightning design. But I was already starting to suffer seller's remorse about swapping the belt.

I could tell Tony's heart wasn't in it. But I also knew he wanted to make me happy. He smiled and said, "Okay, fine," and handed over his Carico Lake turquoise ring. While I knew it wasn't the ultimate example of his jewelry, I was thrilled. I now owned a Tony Abeyta ring.

After our deal was consummated, Tony said, "If you really like great Indian jewelry, you should visit my friend Aaron Anderson in Gallup."

"You know, I was thinking of going to Gallup this weekend."

"Great, why don't I give him a call so that he expects you," offered Tony.

A few days later, I headed west down Highway 40, past an astonishing stretch of red sandstone mesas. There was a constant flow of trains in the

distance, their multi-colored boxcars becoming mesas of their own. The clouds above morphed before my eyes into a "pod of whales"—to quote the New Mexican poet John Macker. Once I completed the 200-mile drive, I checked into the venerable El Rancho Hotel, and then called Aaron Anderson. Since it was the weekend and he wasn't in his main studio, he insisted that I come out to his house. When he opened the front door, I was taken aback by his intimidating presence. Aaron was a large man, perhaps six-one, long hair, and a wispy beard. But, his welcoming smile quickly lightened the mood. Aaron introduced me to his wife and two children, with an overwhelming sense of pride. It was clear to me that his family was the most important thing in the world to him.

Still, I felt slightly uncomfortable. We were strangers who came from two different worlds. Out of the corner of my eye, I noticed the Arizona Cardinals football game was playing on their jumbo flat screen television. A bit of a football fan myself, I sat down and watched a quarter with Aaron. Whatever awkwardness existed between us soon dissipated. Suddenly, we were just two guys hanging out, cheering on the home team.

Then I made a mistake and asked for a beer. Aaron explained that he doesn't drink anymore; he had been sober for years. For that matter, so had Tony Abeyta, Diego Romero, and a number of other Indian artists I knew. I noticed a correlation between swearing off alcohol and their work's growth. It was analogous to a story I once read about the major contemporary artist Brice Marden. Early in his career, he was a self-proclaimed pothead. One day, Marden woke up and realized smoking weed was robbing him of his ambition. He was growing lazy and less introspective about his work. He knew he had to make a decision. Did he want to be pot smoker or an artist? Fortunately, he chose the latter. Not long after, Marden began producing some of the best work of his life.

Aaron brought me up to date on his career. He had become something of a rock star in Japan, a nation with a high regard for American Indian jewelers, which treats Charles Loloma as a god. Dealers have flown Aaron to Japan to give lectures and jewelry making demonstrations. He told me how he had become a mentor to young jewelry designers, including Kevin Yazzie, emphasizing his desire to give back to the community. It was something I had seen too little of in the Indian art world. My observation

was that most of the artists who made it quickly abandoned any ties to their pueblos or reservations. In fact, one artist told me about his fear of getting sucked back into poverty if he hung out with his people. He likened it to a pot of live crabs, where one manages to climb onto the backs of the others, reach the top, and then gets pulled down by the other crustaceans struggling to escape.

Aaron waved, "Come on out back. I'll show you my workshop."

Once inside the cramped space, Aaron unveiled half-a-dozen tufa cast bracelets, which were in various stages of production. Tufa casting is a process where the artist takes a small block of finely textured volcanic stone and carves a design into it. This creates a mold. He then uses a blowtorch to heat up some silver until it reaches a molten state. Sometimes, pre-1965 American silver coins or silver Mexican pesos are used, which is referred to as "coin silver." Next, the artist places a matching flat block on top of the carved block, ties them tightly together, and pours in the liquid silver through a small channel that's been hollowed out. Finally, he immerses the "sandwich" into a bucket of cold water. The metal hardens instantly. He then unties the tufa blocks and extracts the finished strip of carved silver. A grinding wheel is used to trim the excess metal. You might even use some jewelers rouge to polish some sections. From there, the artist will take a rawhide mallet and pound the strip into a bracelet, using an anvil to help shape it.

I pointed to a finished band with a pattern of multiple abstract sunbursts and said to Aaron, "I really like this one."

He nodded, "Great. Why don't you pick out a stone that I can mount on top of it."

With that, he grabbed a leather pouch and poured out a small mountain of polished pieces of turquoise for me to sort through. Feeling a bit of self-imposed pressure to make a rapid decision, I selected one and handed it to him.

"That's a piece of Morenci," said Aaron. I was familiar with the Morenci mine in Arizona, known for its sky-blue turquoise, often speckled with iron pyrite.

I said, "How much is this going to cost me?"

Aaron laughed, "Don't worry about it—you're a friend of Tony's so

I'll give it to you wholesale. You're looking at three hundred dollars for the bracelet and just another twenty-five for the stone."

"Great, I'll take it."

"Meet me tomorrow morning at my studio downtown—I'll have it finished by then. That'll give me time to add a dark patina and mount the stone."

I met him the next morning at the appointed spot and the bracelet was ready as promised—and looked great. When you put on a piece of American Indian jewelry, it connects your spirit to the spirit of the artist who made it—a feeling completely different than buying an impersonal Cartier watch or a diamond ring from Tiffany. American Indian jewelry becomes so personal for some owners, they won't let an admirer touch a piece they're wearing, let alone try it on. They fear it will diminish their spiritual connection to it. Personally, I can't resist letting someone slip on one of my bracelets so they can share my pleasure.

§

Once I returned to Santa Fe, Tony Abeyta and I got together for breakfast. He showed up holding one of those miniature glossy gift bags covered in red and green Santas and casually placed it on the table in front of me,.

"An early Christmas present," he smiled.

I took the bag, which seemed unusually heavy for such a small package. It felt like there was a chunk of coal inside. But my fears were soon allayed. I turned it upside down and out tumbled my concho belt.

7

MARVIN SLIM

So what would it take for Native American jewelry to cross over into fine art? To get another perspective I called Marvin Slim, a Navajo jewelry designer with whom I had struck up a friendship, and invited him to lunch at the Santacafé. Marvin is a fixture of the Santa Fe jewelry scene. He has been exhibiting his creations under the portal of the Palace of the Governors since he was twenty-one. It's a competitive environment; spaces are available only on a lottery basis. Every morning at seven, the artisans arrive to put their names in the hat for one of the coveted seventy spots on the red brick walk, each measuring a compact six by four feet—twelve bricks wide, as the exhibitors calculate it. But if lady luck doesn't smile upon you, and your name isn't drawn, it can mean a demoralizing sixty-mile drive back to Albuquerque or someplace even further. For the winners, it means a ten-hour day interacting with tourists, and dealing with their often exasperating ways.

The restaurant was bustling with local businessmen and well-heeled tourists. Every room of the stark white adobe interior is adorned with an impressive rack of antelope antlers, each dramatically lit to create an expressive shadow. The reference to Georgia O'Keeffe is not lost on anyone.

Marvin is a large and handsome man who is unfailingly polite, "So how's Santa Fe been treating you so far?" he said.

I shrugged. "Pretty good, but it's been a hard transition. I'm not sure I knew what I was getting myself into."

Marvin grinned.

"How's Luana doing?" I asked.

"She's great."

Luana is Marvin's wife and also a jewelry artisan. He told me

how they first met under the Palace portal when she was only eighteen and had just begun showing her work. Their courtship was filled with complications because he was Navajo and she was from the San Felipe Pueblo. Specifically, her father was upset that Marvin wasn't a member of the same tribe. He eventually won him over, but most elders feel strongly about marrying someone from your own tribe. The Navajo also have clans. You're not supposed to get involved with someone from your own clan. It's not considered incestuous—but it's close.

The waiter arrived with my crispy calamari and four chile lime dipping sauce. I said to Marvin, "Tell me about making a living under the portal—the whole thing seems precarious to me. What happens if you lose the lottery two days in a row? If you work five days a week, that's forty percent of your income."

Marvin explained, "I have a standing deal with two of my friends to share a space if one of us loses. It's a little cramped, but it always works out. Although it does seem to upset some of the others who don't have friends willing to strike a similar arrangement."

For over twenty years, Marvin has supported his wife and two children on what he's earned at the Plaza. His life is a mix of social contrasts; time alone in the studio balanced by interaction with his audience and the camaraderie of his fellow vendors. He's allowed to keep 100% of everything he sells, as opposed to about 50% if he consigned his work to a gallery. When tourists try to negotiate, he explains to them "this isn't a flea market." Marvin often suggests they take a walk around the Plaza and check out the prices at the upscale jewelry shops.

Marvin continued, "Well, I'm fortunate my jewelry sells and I enjoy creating it. But it's not that simple. The public thinks we have this easy life sitting on our asses. Try doing it in the bitter cold in January. But what really gets me is all the pettiness that goes on among the artists. We have members from over twenty different tribes exhibiting here. There are jealousies over who's selling, who has the best location, you name it. Someone—I don't know who—must have had it in for me because a rumor got back to my wife that I had a thing for one of the female exhibitors." Marvin paused, then grew angry, "I have a beautiful wife who I love—the whole thing was ridiculous."

Switching gears, I queried, "I've always wanted to ask you this, but what's the craziest thing a tourist has ever said to you?"

He chuckled, "Most of the people are pretty nice and respectful. But I do remember when some joker said to my uncle, who's also a jewelry designer, 'Where are all the Indians? I thought all you guys had feathers?' So my uncle says to him, 'I'm an Indian, not a chicken.'"

"Great comeback," I laughed.

Our waiter approached the table, "Gentlemen, will you be having dessert?"

Knowing of the Santacafé's reputation for outstanding desserts, I said, "Definitely. What do you have?"

But Marvin cut the waiter off. "Sorry, Richard. I have to get back to work. We're only allowed an hour for lunch. We've got all these rules and if you violate enough of them, you lose your space." Then he said, only half in jest, "If I'm late, someone might tell on me." He stood up, "Come on, let's go."

I handed the waiter my credit card and we were off.

I walked with Marvin to the Plaza, filing past the long row of sellers. Out of the corner of my eye, I noticed a vendor glance at his watch and then look up at Marvin; he really wasn't kidding about the pettiness of his colleagues. Marvin took a seat and removed the blanket he used to hide his jewelry when he was away. A couple walked by and bent down to take a closer look. Before long, the wife reached for a ring and tried it on. Moments later, her husband reached for his wallet.

§

While at the Plaza, I walked over to Tony Abeyta's studio to say hello and thank him for generously giving me back my concho belt. I found him standing in front of his easel. There was a medium-size canvas resting on it, which depicted a Taos landscape covered with small adobe homes, lining a winding dirt road. Typical of his work, the sky was a remarkable configuration of volumetric shapes, whose colors ran the gamut of blue

minerals, from azurite to turquoise to lapis lazuli. Smack in the center of the picture was a flowering tree, covered in thick pink blossoms, the color of cotton candy.

Tony called out, "Hey Polsky, do you see anything that might improve this painting?"

That was one of the things that I admired about Tony; he was always willing to listen to constructive criticism. In fact, he encouraged it.

"Hmm," I said, carefully scrutinizing his composition. "No, it looks finished to me."

After catching up, the conversation drifted to how he came to acquire his Agnes Martin paintings, which had caught my eye when I saw them at his home. Tony explained that once Martin passed away, a few of her small paintings ended up with her framer in Taos. Not long after, the framer also died. One day, Tony received a call from his widow, who knew he was a fan of the work. One thing led to another and Tony bought two small Martin canvases from her. But they were never signed, leading to all sorts of potential complications to get them authenticated. Though they were clearly genuine, Martin's estate was controlled by her long-time dealer, Arne Glimcher, who owned Pace Gallery. Since virtually all of her work passed through his gallery, he was leery of any "outside" paintings that showed up.

Hoping to arrive at a strategy, we left the studio and began walking around the Plaza, looking for a place to have coffee and continue the discussion. Before I knew it, I had lost Tony. I turned around and found him standing in front of a pay phone. I watched in amusement as he reached into his pocket, extracted a bunch of quarters, and carefully deposited them in the little coin trough at the bottom of the phone.

As the flap closed with a wobbling metallic sound, I asked with a smile, "What are you doing?"

Tony smiled back, "When I was a little kid, I used to always look inside coin returns, hoping to find some money."

"Yeah, me too. I even looked inside newspaper boxes and cigarette machines," I said with a nod.

Tony grinned, "Can you imagine how happy I'm going to make some kid when he finds all that change?"

8

ROOTS

It was late August and the scent of roasting chiles permeated Santa Fe's thin air. I tracked the smell to the Santa Fe Farmers Market, located in the Railyard District. It overflowed with a wide variety of produce, but the real action was at the stalls where they roasted chiles. The peppers are cooked in a contraption which is an ingenious combination of utility and simplicity. Essentially, it is a steel oil barrel whose sides were replaced with a mesh grating, mounted horizontally on a giant rotisserie. There is also a metal basket at the bottom designed to catch excess charred skin and seeds, typical collateral damage from the roasting process. As the roaster hand-cranked the barrel slowly over an open flame, the chile vapors worked their magic, enticing market-goers to line up for their rightful share of peppers.

And line up they did. The going rate was seven dollars for a Ziploc bag filled to the point of bursting. You had your choice of mild, medium, or hot peppers. However, as essential as they are to the New Mexican culinary experience, their pleasures don't come easy—they have to be earned. Once you bring your peppers home, it's time to go to work. You have to scrape the blistered skin off the surface and gut the interior to remove the seeds. A roasted pepper is slippery; it's like holding a slimy salamander in your hands. What's more, the seeds have a tendency to stick to the inner wall of the pepper, forcing you to pick them off individually. As I once heard a local chef remark, "Peeling chiles is the hardest job in Santa Fe."

Indulging in green chiles was just one of Santa Fe's myriad of pleasures. It also made me realize that to understand the local art scene, you needed to put it into context. Perhaps there's no one better to explain

Santa Fe's recent history than longtime resident and artist Doug Magnus.

Meeting Doug is like taking a trip back to Santa Fe's glory days. Magnus arrived in the City Different in 1968. Tall and lanky, with shoulder-length hair, a handlebar mustache, and a stylish wardrobe, he was more hipster than hippie. Magnus had driven from California to New Mexico and arrived with ninety dollars in his wallet (gas was only twenty-four cents a gallon). Northern New Mexico was wide-open back then, as far as business opportunities went. Magnus described it as a "big blank canvas." He and a friend hit on the idea of buying rugs in Mexico and then selling them on Canyon Road. At the time, the street was the epicenter of the local counter culture, with only seven or eight scattered shops—a far cry from today's half-mile of galleries.

Around 1972, Magnus caught the wave of the burgeoning American Indian jewelry business. He found he had an aptitude for jewelry design and soon established his own workshop. His timing was impeccable. Almost overnight, silver and turquoise jewelry became a fashion statement which reflected the times; spiritual, ethereal, and totally tuned into the "Indian vibe." The market for American Indian jewelry soon went national; Saks Fifth Avenue was among the high-profile retail outlets.

According to Magnus, "The action in Santa Fe was like the Wild West—the demand was incredible." An unofficial trading center developed in the alley behind the downtown Plaza's Rainbow Man shop. Magnus spoke fondly of the days when traders from all over New Mexico showed up there to buy and sell jewelry, Indian artifacts, and rough turquoise. The market peaked around 1975 when the magazine *Arizona Highways* produced a small series of issues devoted to Indian jewelry. By 1979, the gold rush was over, thanks to an influx of shoddy craftsmanship, fake turquoise, and good old-fashioned greed.

However, Magnus didn't benefit from the boom because he wasn't Native. With that in mind, he moved to Gallup and went the cowboy route, producing designs which incorporated Western motifs. At that point, he contacted the up and coming Ralph Lauren, trying to interest him in some form of collaboration. In 1979, Magnus traveled to New York hoping to meet with Lauren himself. When he arrived, he called Ralph (which you could do in those days), but reached his brother Gerry instead. Gerry

invited him over and took a careful look at Magnus's buckles. But despite being responsive to the work, he didn't have a clue how to market it. Magnus was a tad too early. It wasn't until a year later that Ralph Lauren arrived in Santa Fe in search of the next big thing.

At the beginning of the 1980s, Lauren began hanging around Canyon Road. The neighborhood was in transition. Its nineteenth-century adobes were owned mostly by families who had lived there for generations. During the 1960s and 1970s, artists moved in and established studios. But typical of how artists gentrify a neighborhood and are then pushed out, Canyon Road began to experience an influx of people who wanted to open art galleries and hip boutiques—and were willing to pay for the privilege. One of these new shops was owned by a friend of Magnus's named Marcel Fitzner. His store was called the Desert Son and was among the first to decorate its interior with Navajo rugs and buffalo skulls. On the day Ralph Lauren appeared at the Desert Son, Fitzner was decked out in a cowboy hat, big silver buckle, turquoise bracelet, and cowboy boots.

Lauren looked on in amazement and said to him, "Do you guys really dress like this around here?"

"Yes Ralph, we do." said Fitzner, while literally blowing smoke in his face.

As they say, the rest is history. Lauren returned to his New York workshop, where he laid the groundwork for an influential line of clothing, based on bold patterns from Navajo textiles. Cowboy boots and concho belts followed, as Lauren strove to harness the "craftsmanship, authenticity, and rugged artisanal spirit of the American West," according to his website. Lauren even contracted with Santa Fe art dealing legend Forrest Fenn to supply him with thousands of buffalo nickels to be used as jacket buttons. His fashion statement evolved into an amalgam of Western and Indian styles. As Magnus observed, "Ralph was a great synthesizer of Americana."

During the heyday of Santa Fe Style (roughly 1981–1985), the town's fortunes changed dramatically. Magnus told me the key moment occurred in 1981 when funds from the city's hotel lodger tax were used to hire a public relations firm to put Santa Fe on the map—and it worked. Visitors flocked to the downtown Plaza. Stores which catered to the

locals, including a bakery, tire store, and hardware store, were replaced by the Gap, Banana Republic, and Ann Taylor. Soon, Santa Feans abandoned the downtown, as tourism continued its upward trajectory. A surprising number of affluent visitors were bewitched by the romance of the City Different and bought second homes on the East Side of town. Between 1980–1990, residential real estate values doubled.

Santa Fe attracted a sophisticated brand of tourist during the 1980s, who preferred antique American Indian art to contemporary American Indian art. During those years, there was an influx of visitors from the entertainment world in Los Angeles who were comfortable dropping a hundred fifty thousand dollars on a classic first-phase Navajo chief's blanket. They also supported the trendy restaurants that sprung up, including the Coyote Café. In recent years, the restaurants, hotels, and Plaza shops were still full—but the "quality of tourist" was down. Most are uninterested in buying serious Western art or historic Indian art. They just want to pick up some cheap jewelry as souvenirs and drink a few margaritas at the Coyote Café Cantina, the restaurant's less expensive rooftop eatery.

In a counterintuitive way, this has only made it easier for Tony Abeyta to attract an audience for his work. The small group of collectors, who recognize the real thing when they see it, are only too happy to pay Tony's relatively high prices. They realize that you have to pay up if you want the best. That formula worked for years for Tony, allowing him to earn a steady mid-six figure income. But then he took a calculated risk. He decided to leave his long-time Santa Fe gallery, Blue Rain, for the Owings Gallery.

Tony Abeyta had shown with Blue Rain Gallery for many years. They represented a number of successful artists, including Tammy Garcia, former wife of gallery owner Leroy Garcia. The space itself was located just off the downtown Plaza (it eventually moved to the Railyard District). It was a handsome venue, with tasteful lighting, and beautifully installed exhibitions. When a collector walked in, they immediately realized Blue Rain was a notch above the typical tourist gallery.

Tony soon became Blue Rain's main attraction. The opening receptions for his exhibitions were a major social event. Tony's admirers and collectors packed the gallery. They came to enjoy his magical landscapes,

almost all of which were spoken for. As Tony's reputation rose, he became Blue Rain's best-selling artist. Their two identities became linked. And that ultimately proved to be a problem.

Unlike many Native American painters, Tony was familiar with the international art world, and saw the bigger picture. He was determined to have his work seen in a more important context. At the time, the top gallery in Santa Fe was Gerald Peters. Mr. Peters's reputation was largely based on his association with Georgia O'Keeffe and handling key works by the Taos Society of Artists. His closest rival was the Owings Gallery, which also exhibited important Western art, including the wonderful woodcuts of Gustave Baumann. Both galleries shared a common dilemma; a diminishing supply of quality historic material. The obvious answer was to handle work by living artists.

Tony Abeyta had a discussion with Nat Owings, who had brokered a few pieces of his over time. The meeting went well and they agreed to work together. Nat had an impressive space, good location, and was in the process of opening a second space directly on the Plaza. The Owings gallery was known for well-curated shows and their trademark "tiny square" exhibition catalogues.

Tony Abeyta's decision proved to be smart. Each of his shows at the Owings Gallery was a virtual sell-out and his prices saw a steady rise. Even more important, the new venue energized Tony's work. Simultaneous with finding new representation, Tony rented a house in Berkeley, and began spending part of his year there. He established a studio and soon turned his eye to the surrounding Berkeley hills. The adobes Tony loved to paint morphed into clusters of Arts & Crafts bungalows, which lined the neighborhood's twisting streets. The result was a breakthrough which saw Tony branch out from his New Mexican landscapes to Californian scenery—including a wonderful painting of Yosemite.

As his imagery diversified, his work would became even more sought after. That, coupled with rising prices, would make Tony increasingly more attractive to galleries that showed mainstream contemporary art. The question was whether representation at a serious New York gallery was one of his goals. The answer Tony gave was surprising. As previously stated, his approach was to continue making good work—and get better.

If something amazing were to happen, like a show at the Whitney Museum, that would be cool. But if his life continued on its current trajectory, that was fine too.

9

THE LAST WESTERN POP ARTIST

One of the highlights of living in Northern New Mexico is access to its stunning natural wonders, especially Tent Rocks National Monument. Located within an hour's drive of Santa Fe, its geologic formations evoke the same uncanny atmosphere portrayed in the Peter Weir cult film, *Picnic at Hanging Rock*. You're treated to rows of sandstone spindles each topped with a cream-colored form which resembles a witch's hat. You sense an otherworldly force lurking about; you feel like you're being watched.

But Santa Fe has another natural phenomenon that I found more unnerving; countless large anthills which dot the region. These conical forms, composed of tiny excavated pebbles, average around twenty-four inches in diameter and perhaps twelve inches in height. They have a beautiful symmetry; the ants are pretty fair architects. Their structures cover vacant lots and backyards alike. There are two types of quarter-inch long harvester ants; black and red. The red variety is the dominant species. Both are known to sting. One day at Tent Rocks, I spotted a tall anthill which mirrored a rock formation that stood directly behind it, creating a tableau that echoed the supernatural.

Meanwhile, Santa Fe's weather was changing. It was now late October and the cottonwood leaves were on fire. As for the color of the sky, you could hold up a piece of turquoise against it and watch it disappear. I felt like getting out of the city to see the fall colors and was told to check out Madrid (pronounced MAD-rid), an old coalmining town thirty miles south of Santa Fe. This hamlet was virtually abandoned during the 1950s when the mines played out. Its main drag is dotted with crumbling wooden shacks which once housed the miners. An enterprising realtor listed the whole town for only two hundred fifty thousand. Even

back then, it sounded like a bargain, but there were no takers. During the 1970s, a few enterprising bohemians decided to roll the dice, buying up individual buildings and turning them into funky gift shops and art galleries.

Today, Madrid has become a legitimate arts community. There are several pretty good restaurants, a coffee shop, and a diner constructed specifically for the film *Wild Hogs*. But the town's heart and soul is the Mine Shaft Tavern, a bar whose Wild West vibe attracts a large weekend biker crowd. The Mine Shaft is also a venue for local musicians. I kept hearing that Madrid was the last hippie bastion left in New Mexico and wanted to see for myself.

The road to Madrid is known as the Turquoise Trail, which ultimately ends in Albuquerque. I realized Billy Schenck's studio was on the way and decided to visit him. Schenck is Santa Fe's finest Western artist. Having noticed how Western art and Native American art are often co-mingled by Santa Fe galleries, I wanted to take a closer look at what distinguishes one from the other—and where they overlap.

If asked for a physical description of Schenck, his resemblance to the Marlboro Man wouldn't be a bad place to start. His paintings have a graphic paint-by-numbers quality that you never forget once you've seen one. Schenck arrived in Santa Fe during the late 1970s, fresh from a stint of living and exhibiting in New York's SoHo, where he pioneered the Western Pop art genre. He was highly influenced by Sergio Leone's iconic Western films. He channeled Leone's cool Pop sensibility, which portrayed cowboys as laconic figures who let their guns do the talking. The cowboys felt as detached as Warhol's Campbell's Soup Cans. In fact, Schenck began to refer to himself as the "Warhol of the West."

But eventually New York's Pop scene faded and Schenck's moment of glory passed along with it. He initially moved to Wyoming where he bought and renovated a rustic cabin and surrounding buildings, which he dubbed the Rubber Snake Ranch. It was once featured in *Architectural Digest*. But Schenck felt too isolated, sold the house, and headed to Santa Fe. Here was a place he could stretch out, afford to buy some land, put down roots, and live a gracious New Mexican lifestyle. He proceeded to immerse himself in the region's visual treasures, collecting prehistoric Mimbres pottery,

Navajo blankets, Hopi kachina dolls, Thomas Molesworth furniture, and Taos Society of Artists paintings.

When I walked in, Billy and his long-time muse, Rebecca "Bunny" Carter, gave me a warm greeting. I had never been to Billy's home before and was blown away by the furnishings and fine art. He completely immersed himself in Western culture. Not only did he surround himself with regional art and artifacts, but he wore Western clothes, competed in rodeos, raised cattle, watched cowboy movies, drank beer from longneck bottles, and loved to eat barbecue.

I said to Billy, "Good to see you."

"Good to see you too. How do you like Santa Fe?"

"You know, I really like it a lot here. Although I got to tell you that I've become obsessed with green chile."

"Yeah, that tends to happen," grinned Billy.

I asked Billy about recently switching Santa Fe galleries. He had gone from Manitou to Sorrel Sky. The latter featured a number of Native artists including Ben Nighthorse Campbell, along with a few Western painters. Changing galleries appeared to be a lateral move for Billy. Each program mixed contemporary Western art with contemporary Indian art. It was a survival technique that allowed galleries to hedge their bets, knowing tourists often wanted to buy something with a Southwest theme to commemorate their trip. By offering paintings of cowboys on cattle roundups and Indians performing ceremonial dances, they covered both ends of the spectrum.

The auction houses refer to both Western and American Indian art as Western art and tend to lump them together in their sales. But that's misleading. With the exception of Scholder and the occasional Cannon, the sales are dominated by Western painters. You would think that distinguished Native artists such as Allan Houser, Dan Namingha, and Juane Quick-to-See Smith would be included. But they're not. Interestingly, the Native American artist James Havard, who during the 1970s helped invent a genre called Abstract Illusionism, is never included in Western art auctions. Havard is considered a contemporary artist (few realize he's an indigenous person), so he's placed in Post-War and Contemporary Art sales. This worked for a time. But when the movement he was associated

with went south, so did Havard's star. Had he been categorized as a Western or American Indian artist, he might still have a market today. If all of this is confusing, it's understandable. The greater art market has never quite known what to do with American Indian art.

"So I'm off to Madrid," I told Billy.

He shook his head, "I've got to warn you, Madrid's different. Those folks live off the grid and like it that way. And don't go wandering around the private dirt roads—you're liable to get shot."

I soon arrived in Madrid. Its main drag, only about a quarter of a mile long, was nestled in a shallow valley. Its surrounding hills revealed seams of coal. When it rains, wet coal dust washes down into the town, creating a nasty black sludge that was next to impossible to clean up. Most small businesses keep shovels and sandbags ready. That's the thing about the high desert; you always had to be prepared for summer monsoons and the occasional flash flood.

Almost all of the shops had colorful names like Cowgirl Red and Weasel & Fitz. These small enterprises offer Indian jewelry, local Cerrillos turquoise, hippie scarves, used cowboy boots, and, of course, smudge sticks. Smudge sticks are small bundles of locally gathered sage tied together with thread. Tradition has it, when you burned one in your environment, it "cleared" your house of negative energy. The going rate fluctuated between three dollars and six dollars a bundle, depending on the ambition of the seller.

As I progressed toward the end of the strip, I came to the Mine Shaft Tavern. Its modest outdoor front porch and large dining room are connected by a long enclosed walkway designed to resemble the dark entrance to a mine. The entire exterior is painted black. The lone concession to color is a tremendous mural on one of the exterior walls which depicts scenes of daily life in Madrid. The town's residents love to point to likenesses of themselves and their dogs.

That day, the parking spaces in front of the Mine Shaft were jammed with motorcycles. Most couples were dressed from head to toe in black leather. Blue or red paisley bandanas tied around their foreheads completed the look. You sensed they were accountants and schoolteachers during the week. But come Saturday and Sunday, they cut loose and paraded around

like bad asses. I got a kick out of the men who wore patches sewn onto their vests, claiming some sort of tough guy motorcycle club affiliation. Hells Angels they were not. On the other hand, who was I to talk? I was wearing a fancy cowboy hat, a vintage sand cast Navajo buckle, and a black pair of custom made Paul Bonds with an orange Gila monster crawling up each boot.

I walked up the creaky wooden stairs to the Mine Shaft and took a seat outdoors. A young waitress approached me. She wore a sleeveless blouse, short skirt, and snakeskin cowboy boots that had seen better days. Needless to say she was covered with extensive ink. One of her tattoos was exceptional; a highly-detailed composition of Adam and Eve intertwined with a serpent.

"What can I get you?" asked the waitress.

"What type of beer do you have on draft?"

"No draft—only Rolling Rock in bottles and Pabst Blue Ribbon in cans."

"How much is a 'rock?" I asked, feeling a bit nostalgic. I hadn't had a Rolling Rock since my youth in Cleveland.

"Two bucks—same as a PBR."

I went with the Rolling Rock for old times' sake. I slowly sipped my beer, letting the lazy afternoon unfold. To the left of me was a group of six men and women clustered around a white plastic circular table. As I caught snippets of conversation, I could tell they were townies. Everyone was chain-smoking and one of them had a large tin of tobacco in front of him so he could conveniently roll his own—which he seemed to do quite frequently.

Before long, a tall woman stood up and gestured to me, "Hi, I'm Amy Windels. Are you from around here?"

"Sort of. I recently moved to Santa Fe—this is my first time in Madrid."

With a welcoming smile, she said, "Why don't you come join us?"

I slid my chair over five feet. Amy made introductions, filling me in on the names of her friends. Among the group was her fiancé Tim Arnold, a guitar player who was tuning up before going on stage at the Mine Shaft. Like Amy, Tim was tall. He had long red hair, a pointed devil's goatee, and

was decked out in well-worn cowboy duds. A few moments later, Tim and his fellow musician Jim Almand plugged their guitars into a pair of amps. Jim wore his hair long, his jeans tight and ripped, and his cowboy hat low on his brow. He also had a black eye patch, which reinforced his outlaw persona.

A crowd of perhaps two dozen, in various stages of inebriation, looked on in anticipation. After a brief introduction, the two musicians slid into *Rock and Roll Woman*, a Stephen Stills composition from his Buffalo Springfield days. Jim's vocals wrapped themselves around Tim's smooth guitar work. The duo was tight, anticipating each other's moves; they had played together for years. Amy asked, "So how do you like Madrid so far?"

All I could say was, "This is pretty sweet."

§

I was driving around Santa Fe and saw a sign for an estate sale. Local estate sales often contain Navajo rugs, American Indian artifacts, kachina dolls, and other Native American items. Sure, there were also your fair share of dream catchers and Kokopelli-related pieces. But by and large, people in Santa Fe, especially those wealthy enough to own a vacation home there, tend to furnish their place with high quality art. Often, they'd splurge on regional talent, seeking to embrace their adopted hometown.

This was the case when I walked into an estate sale that day. Though I had arrived late in the afternoon, and the place had been picked over, I noticed a striking painting hanging on the wall. It was a picture of two imposing "Evergreen Dancers" in full costume. I looked up and down the 36" x 30" oil on canvas but couldn't find a signature. Then I detected a faintly lettered name that read Ann Newman. I was surprised that this macho image was painted by a Native woman.

I approached the painter Frank Buffalo Hyde, whose day job was working for the Stephen's Consignment Gallery. We recognized each other, from frequenting the Cowgirl saloon.

"How are you Frank?" I said, while pointing at the painting. "Do you know anything about the artist?"

"I've never heard of Ann Newman—but evidently she can paint," he said.

After some spirited negotiating, I bought the painting for only four hundred dollars. As soon as I hung it in my home, I poured myself a glass of wine and let the picture's beauty wash over me. I then googled Ann Newman but could find nothing on her. In a happy coincidence, not long after I found another one of Newman's pictures at a consignment store. I looked on the back of the canvas, to see if there was any information on the artist, and discovered a short biography. The owner of the shop was kind enough to make a copy of it for me. It turned out Ann Campbell Newman was of Choctaw-Chickasaw ancestry and a former model with a BFA degree from the University of Oklahoma. She spent only one year painting in Santa Fe (1979). There was also a picture of her. What haunted me was how good she was and why there was no trace of her on the Internet. It made me wonder how many other Ann Newmans were out there in the Native American art world who had fallen between the cracks.

* * *

10

MILE-LONG HOT DOG

If there's one thing Santa Fe takes seriously, it's Christmas. I was amazed by the town's extensive holiday preparations. The Plaza's trees were draped in a massive tangle of multi-colored light bulbs, which by night glistened like skeins of spun sugar, reminiscent of a Jackson Pollock. But the real visual treat was far more subtle. Many of the federal buildings, private residences, and Canyon Road art galleries lined their rooftops with farolitos. A farolito is a small brown paper bag which houses a votive candle imbedded in a scoop of sand to keep it from blowing over. Typically spaced thirty-inches apart, in a continuous line which traces a building's perimeters, they illuminate the evening sky with sparkling low-hanging constellations.

With Christmas Eve only hours away, I walked down Canyon Road as the neighborhood merchants were preparing for what's become a running tradition. Every Christmas Eve, Santa Feans turn out in droves sporting their finest (and warmest) Western jackets, to parade down the half-mile long, gallery-lined block. Entire families, dogs in tow, find themselves caught in a scrum of friends and neighbors, reveling in the pageantry of it all. Many of the galleries stay open to welcome visitors with warm apple cider. Small bonfires fill the air with piquant pinyon smoke. People turn out not only to celebrate the holiday, but to create a sense of community, and remind themselves how lucky they are to live in Santa Fe.

That afternoon, I watched a worker line the rooftop of Morning Star Gallery with electrically lit farolitos. Their space was filled with classic American Indian art. Hand-painted Cochiti drums were stacked on top of one another like the Leaning Tower of Pisa. Pairs of beaded moccasins projected from the wall as if they were Donald Judd Minimalist sculptures.

Piles of folded Navajo blankets, each more beautiful than the last, nested on a hand-carved New Mexican pine wood table. Joshua Baer once helped run the gallery, laying a strong foundation for its current success. Over the years, Morning Star changed hands and is now owned by Nedra Matteucci. She is also the proprietor of an eponymous gallery which specializes in historic Western art.

I strolled through Morning Star and was quickly tempted by a silver bolo of a thunderbird, inlayed with turquoise, jet, and orange spiny oyster. While I tried on the Zuni treasure from the 1940s, Nedra and Richard Matteucci walked in. They exhibited an easygoing warmth toward each other that I assume evolved over a long marriage. I heard Richard was once the largest liquor distributor in the state of New Mexico. He sold his holdings many years ago and bought his wife the old Forrest Fenn Gallery.

When I met Nedra that day, I remarked, "You know, whenever I visit your other space, you always have a wonderful Martin Hennings painting on display."

Nedra smiled, "Do you want to see one of the greatest Hennings of all time?"

"Sure," I said with enthusiasm.

Before I knew it, I was whisked away to Nedra and Richard's adobe home, which was set back from the gallery. Built in 1830, it was as gracious and mellow as the Matteuccis. The walls were adorned with major canvases by Taos artists Nicolai Fechin, Joseph Sharp, and Walter Ufer. Then came the main event. The family room featured the Martin Hennings painting Nedra spoke of. It depicted three American Indians on horseback, one wrapped in a red blanket, lost in a valley of amber-tipped silvery green chamisa. A panorama of Northern New Mexico serenity unfolded under a Bisbee blue sky, surrounded by the aubergine-tinged Sangre de Cristos. This picture displayed everything that made Hennings, in my opinion, one of the top five painters of the Taos Society of Artists (along with Ernest Blumenschein, Buck Dunton, Victor Higgins, and Walter Ufer). As Nedra explained, "I bought the Hennings in the nineteen nineties from Forrest Fenn. Works like this are no longer available—at any price."

My tour progressed to the kitchen, which was filled with paintings of pigs and porcine decorative objects. When I pointed this out to Nedra,

she responded, with a laugh, "Well, we used to have a pet pig. Some people have dogs, we had a pig."

What was his name?" I asked.

"Hamilton—or 'Ham' for short."

Then Richard spoke, "Listen, we're having our annual Christmas Eve party. Why don't you join us—you're welcome to bring a friend if you'd like."

A few evenings later, I arrived at the Matteucci residence at around six, after picking my way through Canyon Road, which was already clogged with holiday revelers. The Matteuccis went all-out. Their tented yard was surrounded by oversized Christmas ornaments dangling from the trees; the Seven Wise Men were prominently featured. Several security guards were stationed at the entrance, though they were relaxed about allowing the throngs of Santa Feans to have a peek.

The house was already packed with friends, relatives, and gallery clients. I expected guests to be decked out in festive Western attire but virtually everyone wore regular dress clothes. Not surprisingly, given Richard's background, the two bartenders poured high-end whiskey and expensive wine. The catering was also superb; trays of sliced rare filet mignon, roast turkey, baked ham, and the usual condiments. Surprisingly, there was not a dash of green chile in sight.

The next day, inspired by the 1930s Martin Hennings canvas, I decided to visit Canyon Road's Zaplin-Lampert Gallery. Along with Owings and Gerald Peters, they formed the "big three" of Santa Fe's blue-chip dealers. When I walked in, I was greeted by gallery partner Richard Lampert. After showing me around, I looked in his office and noticed a large Fritz Scholder painting hanging over a sofa.

I said to Richard, "Do you normally deal in Scholder's work?"

"Occasionally," he replied. "I'm always interested if it's a good early piece. But I'm much more interested in acquiring work by T.C. Cannon. Know of anything?"

I didn't. But I certainly shared Richard Lampert's enthusiasm for his art. T. C. Cannon was a student of Scholder's at the IAIA who went on to briefly challenge his teacher for dominance in the Native American art world. Cannon's work was a little more Pop-oriented and a little

edgier than Scholder's. Though both artists created paintings that spoke of past injustices inflicted on Native Americans, Cannon's work hit harder, probably because he came of age as an artist during the heyday of the American Indian Movement. Cannon's best pictures displayed a reverence for the past, while slyly shining a light on the plight of the modern day American Indian.

Many of Cannon's paintings which depicted difficult subject matter were still decorative enough to hang in your living room. A good example is *Beef Issue at Fort Sill*. This grisly picture depicts a steer that has just been slaughtered, its guts and intestines spilling out of a cavity in its stomach. The painting recalls the shameful days of the Long March, when thousands of the remaining members of the Navajo tribe were forced onto a reservation, where provisions were vastly inadequate. Cannon's palette is vivid; his choice of colors are surprisingly jubilant. The painting made such a memorable impact that Jamake Highwater chose it for the cover of *The Sweet Grass Lives On*.

Cannon's work was represented in New York by Aberbach Fine Art, located on Madison Avenue. While they weren't in the same league as Leo Castelli, they had a respected, if slightly commercial program. The gallery's owners, Joachim and Jean Aberbach, made their fortune by acquiring the publishing rights to Elvis Presley's music. Jean Aberbach came across Cannon's work for the first time in 1972, at a show titled "Two American Painters," at the Smithsonian. Fritz Scholder had originally been offered the exhibition and was allowed to choose a second artist to share the stage; he chose Cannon. Jean Aberbach and his wife attended the opening and were smitten with Cannon's work. They approached him that evening about handling his paintings, even offering a monthly stipend against future sales. Cannon soon signed a contract which provided him with enough money to move to Santa Fe from Oklahoma. With financial security, and the ego boost provided by having a highly visible New York gallery, he made great strides as a painter. He was well on his way to exceeding Scholder, both aesthetically and financially, when, in 1978, he was killed in an automobile accident. Tommy Cannon was only thirty-two.

Part of the tragedy was that Cannon was relatively unknown when he died. He was also far less prolific than Scholder. Given his compelling

personal story, short life, and the scarcity of his paintings, he developed a cult following. I was aware of the demand for his work on the day I received an email from the Santa Fe gallery Windsor Betts, offering a T.C. Cannon painting called *Small Catcher*. I could scarcely believe my eyes, having never seen a Cannon for sale before. The 36" x 30" canvas portrayed a Hopi dancer clutching a handful of writhing snakes and a few eagle feathers, with a pueblo looming in the background. The asking price was sixty-five thousand, but I had a feeling it was worth more. I probably should have tried to buy it, but was unfamiliar with Cannon's market. Instead, I contacted Richard Lampert, who walked over to Windsor Betts, bought the painting, promptly sold it, and paid me a nice finder's fee.

I called Tony Abeyta to tell him about my deal, expecting him to congratulate me. Instead, he sounded hurt, "Why didn't you offer it to me?"

"You would have bought it?"

"I might have. I already own one," said Tony

"Which one is that?" I asked.

"Don't you remember seeing the *Mile-Long Hot Dog* at my place?"

The last time I was at his home, I did recall a small painting of a life-size skinny red hot dog, protruding from a much too small bun, on a yellow ground.

"I bought it mostly for the story. I was told that T.C. and a buddy were on a road trip in the Southwest, saw this sign for mile-long hot dogs, and decided to pull over to have one." With a grin, Tony mused, "I can just see Cannon sitting there, wearing his cowboy hat with a feather sticking out of it, eating that hot dog slathered in mustard..."

The irony wasn't lost on me. Had Cannon lived, and kept the painting, it easily could have paid for the entire hot dog stand—and a year's supply of frankfurters.

...

11

GEORGIA ON MY MIND

Few people have a sense of how Santa Fe became America's premier art center for Western art and American Indian art. It largely started with Forrest Fenn, who, with a little help from Gerry Peters, laid the groundwork for today's robust scene. I decided to meet Fenn at the Down Sub to hear more of his story. I strolled into the café as he stretched out his hand to greet me. Fenn was dressed in a cowboy hat, blue work shirt, a red bandana tied around his neck, a pair of well-worn jeans, and the same turquoise inlay belt buckle he's worn every day since the 1970s. He was tall, with ramrod straight posture that was a tribute to his days in the military. He gave off the charismatic glow of a gentleman rancher. What threw me, though, was the twinkle in his blue eyes; a mischievous look that seemed to say, I may be old, but I'm still a player.

We then "traveled" back to 1972 when Fenn first arrived in Santa Fe. According to Fenn, the City Different was not on anyone's radar; few Americans had even heard of it let alone visited. Confirming what Doug Magnus once told me, many of its roads were unpaved, artist studios occupied Canyon Road, and there was no tourism to speak of. It was populated with hippie transplants from California, looking for cheap rents in an exotic locale, while hoping to connect with Indian spirituality.

Against this backdrop, Forrest Fenn took some of his Air Force retirement pay, after serving for twenty-years—including flying 328 combat missions in Vietnam—and built a tremendous adobe-style gallery adjacent to Canyon Road. The early going was tough but Fenn managed to stay afloat, thanks to income generated by a bronze foundry that he owned

and operated. During that decade, the Santa Fe art market was still trying to find its legs. With the exception of Georgia O'Keeffe, New York could have cared less about art generated in New Mexico.

For years, the New York art establishment overlooked the Taos Society of Artists, who more than held their own against their East Coast counterparts, including Edward Hopper. By the 1970s, most of the club's artists had passed on and their estates languished with inexperienced and sometimes uncaring relatives. Fenn made his move, buying up their legacies and promoting the hell out of them. His shrewd marketing included writing and publishing books on Nicolai Fechin, known for his portraits painted with agitated brushstrokes; Joseph Sharp, who featured American Indians in traditional settings; and Leon Gaspard, a Russian immigrant painter of both Russian and Native American cultures. In due course, Fenn helped establish a meaningful market for their paintings and the rest of the Taos school.

Fenn parlayed his penchant for hard work and risk-taking into an art dealing empire. Along the way, he became a bona fide Santa Fe character. Based on the stories I heard, he was as dedicated to having fun as he was to making money (probably more so). For instance, there was a pond in the backyard of his gallery, which contained two live alligators, named Beowulf and Elvis. He also placed a larger than life-size metal buffalo sculpture on a small plot of ground he leased from the city. Art critics took exception to his use of public space for a work owned by an art dealer. One morning, Fenn drove by the bison only to find four bullet holes in its side, the result of potshots taken by a would-be Buffalo Bill. Doing what any savvy art dealer would do, Fenn called the paper, which ran a photograph of the wounded animal. Now that the sculpture was famous, he raised the price and supposedly sold it immediately.

As the art market gathered momentum during the 1980s, Fenn made enough money to branch out into other investments, including real estate. Once he and his family had achieved financial security, he indulged himself in his true passion; collecting and hunting American Indian artifacts. He even managed to buy a five thousand room ancient Native pueblo; only one percent of the ruin has been excavated. Fenn became so enthralled with his hobby, that he eventually assembled a museum quality collection

of artifacts that reverberates with American history. One of his proudest acquisitions is Sitting Bull's peace pipe—a relic he values at around a million dollars largely because it's fully documented.

Realizing his personal interests outweighed the time he spent at his gallery, he sold it to Richard and Nedra Matteucci. Once Fenn turned eighty in 2010, he took stock of a life well-lived. Among his many achievements, he expressed his pride in his sixty-year marriage to Peggy, his two daughters, and seven grandchildren. But he was also aware that he was in the process of writing the last chapters of his life, having recently survived cancer.

That's when Forrest Fenn made his move. He took a centuries-old bronze chest and filled it with approximately two million dollars in gold coins, jewels, and American Indian artifacts. (In 2020, the treasure was allegedly found in Yellowstone National Park in Wyoming, only a few weeks before Fenn's death.) Then he buried it somewhere in the Rocky Mountains north of Santa Fe. Next, he wrote a poem, which offered nine clues for finding the treasure. The poem was published in a memoir he authored called *The Thrill of the Chase*. As you might guess, it became a local best seller. The story received so much national publicity that Fenn soon found himself as a guest on the *Today* show and *Good Morning America*. As an octogenarian, he was having the time of his life.

Not all of Santa Fe was thrilled with this development. Tony Abeyta took issue with it, explaining how centuries ago American Indians from the surrounding pueblos would bury their valuables in advance of invading Spaniards. Tony found it offensive that a wealthy Anglo thought that burying a treasure and having everyone run around searching for it was a lot of fun and games, when it was symbolic of survival for his ancestors. Tony's position reflected the peculiar sensitivities of life in Santa Fe. One had to consider the diversity of its population when you planned publicity stunts, even if they appeared harmless on the surface.

What impressed me most about Fenn were the life lessons he absorbed during his long existence. As someone self-made, his success wasn't based on being born into privilege and wealth. Forest Fenn's message was you have to have an imagination, you have to think big, and you have to work hard. Oh, and a little luck never hurt.

Fenn's efforts to forge a Santa Fe art market were augmented by Gerry Peters. For a while, the Gerald Peters Gallery was the only program in Santa Fe with a national reputation. Much of it was based on handling the work of a lone artist, Georgia O'Keeffe. Though O'Keeffe was already a household name, her market lagged far behind her blue-chip contemporaries. Peters's particular genius was that he recognized O'Keeffe was a living myth, whose art was undervalued because it was overshadowed by the world's fascination with her exotic lifestyle. Here, in his own backyard, was an incredible body of work ripe for exploitation.

Gerry Peters managed to befriend Juan Hamilton. As all O'Keeffe aficionados know, Hamilton was O'Keeffe's assistant and companion, fifty years her junior. Naturally, much was made of his good looks and resemblance to her deceased husband and mentor Alfred Stieglitz. There was a lot of scuttlebutt about the personal nature of their lives together. From everything I read, it sounded like their friendship was genuine and their business dealings were mutually beneficial. Late in O'Keeffe's career, Hamilton functioned as her dealer. From what I could discern, he did an outstanding job controlling her market.

Regardless of the truth about their relationship, Hamilton was an underrated artist in his own right. His career as a sculptor was eclipsed by the notoriety of his life with O'Keeffe. Hamilton's art consists of ceramic and bronze organic forms that resemble well-worn boulders. His shapes have a Zen-like quality. When you see one, you want to run your hands over it just to confirm its smoothness. Yet, they have an edge that goes beyond mere decorative objects. Juan Hamilton's work is the real deal.

Peters recognized this, eventually representing Hamilton, and leveraging their relationship into an introduction to O'Keeffe. At the time, O'Keeffe's exclusive agent was a woman on the East Coast named Doris Bry. While Bry received a commission on any sales that she arranged, Peters decided to go one better. He proposed to O'Keeffe that she keep all of the money when he sold one of her paintings. Instead of taking a commission, he requested a credit. As his credits accumulated, they would eventually be applied to being given a painting.

It was a smart business arrangement that worked well for both parties. O'Keeffe never had to surrender any of the money when a painting

of hers sold. Peters could defer the taxes he would have had to pay on his commissions, while also accumulating an inventory of O'Keeffe paintings that were constantly appreciating. Once Peters had acquired a number of pictures, he began paying record prices for O'Keeffes which came up to auction at Sotheby's and Christie's, which also increased the value of his inventory.

I wanted to meet Juan Hamilton, hoping to shed further light on O'Keeffe because of her singular importance to the Santa Fe art scene. Though he now spent most of the year in Hawaii, he still maintained a studio in Santa Fe. Part of my desire to get together with Hamilton was triggered by a recent visit to the Georgia O'Keeffe Museum. It was founded in 1997 by John Marion, the superstar auctioneer and former chairman of Sotheby's, and his wife Anne, a member of Fort Worth's Burnett oil family. As lifelong O'Keeffe fans, their personal holdings of her work formed the core of the museum's collection. The show I saw that day was a group of pictures painted at Stieglitz's summer family retreat at Lake George, in upstate New York. After viewing the featured exhibition, I walked around the rest of the museum to take a look at the permanent collection. That's when I noticed a number of paintings were donated by Juan Hamilton. When O'Keeffe died, Hamilton inherited a majority of her estate; a rumored fifty million dollars worth of art and property. In order to offset inheritance taxes, Hamilton gave the museum a number of paintings.

Juan Hamilton is an elusive character. I was told he was wary of being used by people. That's when I solicited the help of Spencer Tomkins, a private art dealer in Manhattan, and the son of the esteemed writer Calvin Tomkins. I was aware Calvin once wrote a flattering profile on O'Keeffe for *The New Yorker*. With that in mind, I called Spencer.

"Hey, it's Richard Polsky calling from Santa Fe."

"What are you doing there?" he asked, sounding mildly amused.

"Believe it or not, I actually live here."

After we spent a few minutes catching up, I asked him, "Would you happen to have Juan Hamilton's phone number?"

Spencer hesitated, "I guess it would be all right to give it to you. But I've got to warn you; he can be difficult. I like Juan, but we once had some

tricky business dealings over a Stieglitz photograph. I wouldn't count on getting together with him. He's very private and he's been burned by the media."

After thanking Spencer, I called Juan. Luck was with me as he answered his phone, "Who's this and where'd you get my number?"

"I'm a friend of Spencer Tomkins—he gave it to me."

"Spencer?" replied Juan, rather testily. "I like his father better."

That broke the ice and made me laugh. "Listen Juan, if you're in town, I was wondering if you'd be up for having coffee? I write about the art world and thought it might be fun to hang out. I've written some books you may have heard of including one called *I Sold Andy Warhol (too soon)*."

Now it was Juan's turn to laugh, "Sounds like something I once did. Andy painted a portrait of Georgia that I unfortunately sold a few years ago—I should have held onto it."

"Believe me," I sighed, "I know the feeling. Anyway, do you have time to get together?"

"Well, I haven't had lunch yet. Want to buy me lunch?"

"Sure," I said with enthusiasm. "Where do you want to go?"

"How about if I meet you at the Tune-Up Café in thirty minutes?" Then he added, "And by the way, I don't do interviews and I won't talk about O'Keeffe."

The Tune-Up is a strictly locals affair that offers a down-home version of New Mexican fusion cuisine. It had quickly become one of my favorite places to eat in Santa Fe; the grilled salmon tacos smothered in green tomatillo sauce are incredible. I arrived at the restaurant and watched Hamilton pull up in a black Mercedes SUV. Juan resembled the actor Sam Elliott. He was tall, seventyish (then), with a full head of dark hair and just a twinge of gray, and of course an impressive mustache.

We were soon seated outdoors, looking over our menus. Things were a little awkward at first. I inquired about his work, but the conversation never gained traction. Then I said, "By the way, I just saw the Lake George show over at the museum."

"Wow, O'Keeffe and nature, what a revelation," said Juan, sarcastically.

He had a point. Juan spoke of his general disregard for the museum and the city's art scene. It wasn't that he was anti-Santa Fe. Instead, I sensed the town never gave him a fair shake, drawing its own conclusions about his life with O'Keeffe without getting the facts.

Between spoonfuls of spicy green chile stew, I kept trying to steer the discussion to his art. I asked, "Do you think I could go to your studio some time? I've seen a few of your pieces at Gerald Peters and would welcome the opportunity to see more."

Juan shrugged, "I don't know…maybe."

Then Juan looked up, "What do you think my Warhol O'Keeffe portrait is worth today?"

"One million-five—maybe more."

Juan could only smirk. Lunch came and went rather quickly. After grabbing the check, I thought about a biography I once read on J. Paul Getty. Whenever the oilman went out to dinner, he never picked up a single check, despite being the richest person at the table (by far). Someone always wanted to curry favor with him so they insisted on paying.

As we said adios, I mumbled something about calling him to see his studio. I also mentioned I'd be happy to give him some feedback on his sculpture. But I knew it would never happen. Juan wasn't looking for approval; he was way past that.

...

12

REZ DOGS

Tony Abeyta was in an expansive mood, freely sharing his impressions of the state of the contemporary Native American art world (and his own career). What came out of our discussion were a number of provocative statements:

"We have as much to say as anyone else."

"The work can be about both identity and personal expression."

"My work is culturally based but I paint what I want to."

"A lot of how my career turns out is beyond my control; it's up to the art world."

§

I gave Cara Romero a call—who was well on her way to eclipsing the fame of her husband Diego. She had just completed a large color photograph, titled *Nikki*, of a crouching female nude (except for her tall brown moccasins). What made the image so compelling was the connection between the woman and the red Navajo blanket that served as a backdrop. The black diamond patterns on the rug mimicked the lines of the model's body and her long black braids; it was hard to determine where the female form left off and the textile began. The photo's strength was its ambiguity. It was both edgy and decorative. You could just as easily see it hanging as

a pinup in a grimy automotive garage as adorning the dining room of an elegant adobe.

Perhaps what impressed me most about Cara Romero's photography was that you couldn't tell it was made by a Native American. For that matter, you also had no idea whether the photographer was a man or a woman. Yet the subject matter was indisputably American Indian. The work overlaps some of contemporary art's finest photography. It relates to William Eggleston's groundbreaking use of color to imbue the overlooked with evocative power—such as a coiled green garden hose. Romero's imagery also aligns itself with the narrative power of the South African photographer Pieter Hugo, specifically his portrayal of the feral "Hyena Men" of Lagos, Nigeria, who roam the streets with vicious hyenas tethered at the end of a heavy chain. Now, Cara Romero was forging her own narrative style and fresh interpretation of color. She was clearly someone to watch.

With Cara Romero on my mind, I drove over to Canyon Road to visit her dealer, the Robert Nichols Gallery. His program is devoted primarily to contemporary Native American ceramics. Diego Romero is the gallery star. But change was in the air. Collectors were stopping by just as frequently to inquire about Cara Romero's work.

When I walked in, one of her major pieces, titled *Nipton Highway*, dominated the back wall of the main exhibition room. It was a panoramic triptych printed with black ink on a silver backdrop, which depicted the young artist Santi Romero standing in the middle of a rural road, holding Cara's baby high above his head. The infant appears to be suspended in space, with nothing but the sky above, as if he's flying. Or, you might interpret the image as bearing witness to the next generation of Romero artists.

§

I received a call from Eric Andrews, the proprietor of 203 Fine Art in Taos. I had purchased my Fritz Scholder, *Indian at Gallup Bus Depot*, from

him. Eric wanted me to take a look at an ink study for the original painting that he had for sale. If nothing else, it was a good excuse to go to Taos. Even better, there was a sacred Deer Dance coming up at the Taos Pueblo.

Pueblo life revolves around ceremonial dances. The Deer Dance, held every January, is one of the most visual. The ceremony honors the deer for providing sustenance for the pueblo dwellers. Keen to see the Scholder sketch and experience a Deer Dance, I began the trek to Taos. The seventy-mile drive took me an hour and a half. Prior to the 1930s, in the days of the arts impresario Mabel Dodge Luhan, it was a full day affair. The twisting mountain road, which parallels the liquid beauty of the Rio Grande River, wasn't paved back then. Automobiles frequently broke down or got stuck in mud or rockslides after heavy rains. But there was an upside to all of this. The arduous nature of the journey from Santa Fe to Taos served to isolate it, allowing the village to remain in an unvarnished state until the 1970s.

When I arrived in Taos, I drove straight to the Pueblo. The magnificent five-story adobe structure, which has been continuously inhabited for over a thousand years, is the metaphysical nexus of the Taos Pueblo Indians. It's open to the public and represents an opportunity to connect with the mysterious spiritual undercurrent that permeates Northern New Mexico. This year's Deer Dance was scheduled for noon, though that was flexible. Native American rituals typically get under way when the dancers and drummers are good and ready. Regrettably, I was unaware of this custom and arrived at eleven. Then I heard the starting time was moved to one o'clock, which soon became two. Normally, I wouldn't mind waiting around, enjoying the ambiance of the ancient Pueblo—still without running water and electricity. But today the temperature hovered in the mid-twenties; not entirely unpleasant but enough to get your attention. Fortunately, I had recently invested in an Overland shearling jacket, one of the warmest coats around.

The long wait was not entirely without its pleasures. I watched perhaps a dozen "Rez dogs" roam the grounds in search of a handout from a compassionate tourist. These mongrels, who were the subject of a number of early Fritz Scholder compositions, led a tough life. Many of them bore facial scars and open cuts from fights. The unwritten rule

at the Taos Pueblo is that if a dog befriends you, he's yours. The few remaining pueblo dwellers were only too happy to have one less mouth to feed. I watched in amazement as a thirty-pound mutt with a brindle coat navigated the frozen creek which bisected the village. He spotted a break in the ice, crouched down low, and proceeded to lap up the freezing water, drinking for almost thirty seconds. When he got up and trotted away, I was overcome with a sense of joy and well-being.

As the time achingly inched toward two, something began to stir in the distance. A woman with long gray hair crossed one of the split-log bridges that divided the two complexes which formed the Taos Pueblo. She was carrying a severed deer head in a basket which peeked out ominously from under a blanket. I strained to get a better look at the surreal scene, but the elder quickly disappeared into one of the pueblo's apartments.

I was startled by a series of loud whoops emanating from the pueblo. Perhaps a dozen striped clowns poured out of a doorway. Each man was covered in alternating black and white bands of ash caked onto his face, bare chest, arms, and legs. Their heads were crowned with dried cornhusks, anchored by a spread-winged stuffed hawk. Clowns play a crucial role in Native American ceremonies. They entertain tribal spectators and visitors alike, but their primary job is to keep the dance moving.

With the approach of the clowns, the audience of around two hundred grew animated. Female members of the Taos Pueblo, wrapped in colorful Pendleton blankets, shoved their way to the front of the circle. At first I was offended by their pushiness, but quickly realized it was their land and their ceremony; I was just a guest.

Right before entering the dance, the clowns stopped to build a bonfire. Drifting smoke quickly flooded the dirt plaza. The atmosphere turned eerie. As the smoke dispersed into distant parts of the compound, the clowns finally moved into the inner circle. The striped jesters pranced about, joking in their native tongue with the women who lined the sixty-foot ring. They responded with shrieks of laughter and the occasional elbow when one of the clowns got too familiar.

Moments later, the crowd turned heads in unison. A procession of approximately forty men emerged from the kivas and glided through the smoke like an apparition. I could scarcely believe my eyes. They were

cloaked in full deerskins with the heads still attached, a reference to how their ancestors disguised themselves to lure deer into an ambush. Each deer head had an evergreen branch wedged in his mouth. As they filed into the circle, their antlers bobbed and weaved, creating a miniature dance of its own. A lone elk appeared with a tremendous rack, forcing the wearer to use both hands to steady its weight. The deer were interspersed between several dancers covered with immense buffalo heads which reached to their shoulders; sunlight ricocheted off each bison's shiny black horns. The leader was disguised as a mountain lion. His young son trailed behind, sporting a spotted bobcat costume, whose trailing tail etched a line in the dust.

The male village elders formed a drum circle within the circle. Rez dogs weaved in and out of the procession. Afternoon sunlight cast long dark shadows against the surrounding brown pueblo, further abstracting its cubist forms. The sacred snow-capped Sangre de Cristo Mountains loomed in the distance like a protective mother. The drummers began to play. Their beat was infectious. I swayed to the rhythm, trying to stay warm, losing myself in the moment.

The syncopated thump of the drums picked up as two women, wearing a white dresses, white moccasins, and white leggings, came to the forefront to lead the procession. Both were adorned with multi-colored parrot feather headdresses and heavy turquoise jewelry. Their male counterparts drifted into place, holding short pairs of walking sticks that only reached to their waists, used to balance themselves as they crouched down to imitate the movements of a deer. The dancers appeared to be in an altered state as they swayed in two parallel lines that merged like an amoeba and then separated. They moved so naturally that man and beast became one. I was only ten feet away when an imposing buffalo passed by. Our eyes locked. For a split-second I stood transfixed, convinced the creature had come to life. My imagination transported me; this remarkable scene could have taken place centuries ago.

Occasionally a husky clown would grab one of the deer, drape him over his shoulder—strength and athleticism were part of a clown's job description—and carry him toward a gap in the circle. What appeared to be safe passage for the deer was really a trap. Two grunting hunters waited

for the animal. One aggressively blocked his escape, while the other mimed shooting it with a bow and arrow. The deer expired as members of the tribe looked on with deep satisfaction. So did I. Attending the Deer Dance was one of the more profound experiences of my life. Access to moments like this was why I had come to New Mexico.

With sunlight fading, I made the short drive over to 203 Fine Art. I was greeted by Eric Andrews, who brought me into his backroom and unveiled the Scholder sketch, which wasn't as fully developed as I had hoped. Of greater interest was learning that Scholder once had a studio in this building. Scholder's first dealer, Tally Richards, was the original tenant. She opened her gallery in 1969 and promoted Scholder when his paintings were considered too controversial for New Mexican galleries. As Richards commented in an interview, "Once I proved I could sell the work, every gallery in the state was after him."

§

I ended up spending the night at the Old Taos Inn. Built by Dr. Thomas Martin, in 1936, its Adobe Bar became the social hub of the town (and remains so). Having stayed at the hotel before, I looked forward to hanging out at the Adobe and taking in some live music. That night they featured a rather strange-looking woman who went by Banjo Annie. Before catching her set, I decided to have dinner at a new restaurant with a name which inspired little confidence, The Love Apple.

I pulled up to a modest whitewashed old adobe church, set back twenty feet from the road. Its steeple was tilted at an awkward angle. The building exuded character. The scene was so striking that it felt like it had been composed by a professional photo stylist. I walked into a dark room and was overwhelmed by the raw beauty of the space. The wood plank floor still retained vestiges of its original blue-gray paint. Each of the ten tables was illuminated by a flickering candle, creating a sense of romance and intimacy. The atmosphere, tinged with vaguely religious overtones, couldn't have been more inviting.

A server stopped by my table and handed me a menu. It changed daily and offered a selection of appetizers and entrées which were locally sourced. It was a difficult choice, but I settled on a first course of polenta with sautéed wild mushrooms, followed by a saddle of grilled Colorado lamb. The charred meat, dipped in mint sauce, was divine. When my glass of cabernet arrived, I toasted my good fortune. By the time I finished a dessert of sea salt and caramel house-made ice cream, all was right with the universe. The combination of marvelous food, beautifully served, in a magical setting, was thrilling.

Once I returned to the Inn, I found a seat in the sunken bar area, ordered a "Horny Toad" margarita (Hornitos tequila with a float of Cointreau), and listened to Banjo Annie do her thing. Annie was accompanied by two female musicians, both as heavily tattooed as she was. When Annie finished playing, I waved her over to my table.

"Great performance—really enjoyed it." I said, while clapping.

Annie, who had close-cropped red hair peeking out from a straw hat, replied, "Glad you like our music. Where are you visiting from?"

"Santa Fe," I replied. "Let me ask you something. How did you get the name Banjo Annie?"

Her face lit up, "Well, actually I just changed it to Banjo Annie."

"What was it before?"

"Annie Banjo."

I was speechless.

§

The Deer Dance will remain in my heart forever. Taos is markedly different than Santa Fe. The Native American vibe ran deeper. So did the sense of community. Though Taos is small, with only 5,600 residents, I felt like I had barely scratched its surface. There was still much to see and experience. Before turning in for the evening, I stopped by the front desk and registered for a second night.

13

R.C. GORMAN'S MODEL

I drove over to the landmark Mabel Dodge Luhan House, which is now a B&B. When I heard they had a room available, I called the Old Taos Inn and cancelled my second night. During the 1910s, Mabel Dodge Luhan was a formidable cultural presence in New York. Like Gertrude Stein in Paris, she hosted an art and literary salon in Greenwich Village. She was also an early supporter of Alfred Stieglitz and Gallery 291—the same gallery which would launch Georgia O'Keeffe. Though her gatherings were a success, Luhan felt unfulfilled, longing to find her true place in the universe.

Mabel's husband, the painter Maurice Sterne, was also restless. With her encouragement, he visited the Southwest, hoping to kick-start his faltering art career. Mabel's instincts were spot on. In 1917, Sterne landed in Santa Fe and was instantly smitten by the region. He cabled his wife that New Mexico might be what she's been longing for. Mabel arrived, only to find Santa Fe too confining and socially uptight. However, once she saw Taos, she felt a deep connection to the neighboring Pueblo and the Native American way of life. Mabel bought land adjacent to the Pueblo and hired a handsome Native American, named Tony Luhan, to oversee construction of a large and eccentric home. There was instant chemistry between the two. The next thing you knew, Tony set up a teepee on her property and began drumming every night, hoping to woo her. Apparently it worked because Mabel divorced Sterne, married Tony Luhan, and immersed herself in Pueblo culture.

Mabel Dodge Luhan wasted little time reviving her salon. Her twenty-two-room home became the nexus for the town's bohemian elite as well as a beacon for painters and writers visiting Taos. Perhaps her most famous houseguest was D.H. Lawrence. Not surprisingly, Mabel's gatherings revolved around strong female personalities. Her crowd included Dorothy Brett, an artist who painted Pueblo life in a naïve style that today would be referred to as Outsider art. There was also Millicent Rogers, a Standard Oil heiress and socialite, who eventually settled in Taos and became a rival of Mabel's. Even Georgia O'Keeffe was an occasional visitor. Though Mabel was thrilled by O'Keeffe's presence, she was also wary of her, claiming she had a thing for her husband Tony.

When I checked into the Mabel Dodge Luhan House, I was offered a choice of rooms. I inquired, "How about Mabel and Tony's bedroom?"

The woman at the front desk replied, "Actually, Mabel and Tony had separate rooms."

"Okay, is Tony's room available?"

"Yes, but I have to warn you that a number of people who stayed in it claim it's haunted."

I ascended a short flight of stairs to the second floor of the three-story house. Tony Luhan's bedroom had several small images randomly painted onto the walls—rumor has it he was the artist. His painting style was primitive but strangely compelling. One illustration was of a buffalo, the other depicted a kneeling American Indian perched on top of a star-filled sky. You could see where someone painted around each of these images, to preserve them, when the room was given a fresh coat of white paint.

Later that evening, I went downstairs to read. That's when I noticed the living room was hung with photographs of Dennis Hopper. I asked the woman in charge about their significance.

"Oh, didn't you know? Dennis Hopper bought this house during the 1970s from Mabel's daughter with some of the profits from *Easy Rider*. He used to call it the 'Mud Palace.'"

Naturally, I had seen the movie, but didn't learn until that night that Hopper lived in Taos and considered it to be his spiritual home. After reading up on the subject, I learned that Hopper hoped to turn

Taos into a center for independent filmmaking. But that never happened. While Hopper struggled to complete his film project, *The Last Movie*, he somehow managed to alienate the community. The town's long-time Hispanic residents didn't care for the Hollywood crowd Hopper attracted. Nor did they appreciate the way he threw his money around, buying up buildings and raising real estate prices—which had a trickle-down effect on the poor residents. Stories about confrontations with the local toughs and the police are legendary; Hopper's mug shot was turned into a famous poster. However, at the end of his life, Dennis Hopper returned to Taos and was given a hero's welcome. When he passed away, he was buried in a cemetery in Ranchos de Taos.

Back upstairs, I sat in Tony Luhan's room staring at his strange little paintings on the wall. Once I got into bed and shut the lights, I failed to detect any poltergeist. But later that night, I was awakened by a pack of howling coyotes. I switched on the light and examined Tony's image of an American Indian bowed in prayer. That's when I noticed how the area surrounding the stars was painted a deep midnight blue. When I looked out the window, the nighttime sky corresponded with Tony's vision; the connection was powerful.

The next day, I wound up stopping by the Tony Reyna Indian Shop, located just inside the Taos Pueblo reservation. It was opened by Tony Reyna in 1950. During World War II, he miraculously survived the Bataan Death March, and returned a war hero and a source of pride to the town. He started his Indian shop as a way to support the local Native artisans. These days, it's run by Tony's son Phillip, whom I had met on a previous visit.

When I tried to open the front door of the store, I found it was closed. As usual, there was a pack of mutts lounging about, soaking up the mid-morning sun. I was about to leave when I heard a lady in the parking lot yell out to me, "Howdy. Are you looking for Phillip?"

"Yes, I am."

"That makes two of us," she laughed.

The woman was standing in front of an old battered pick-up truck with the requisite cracked windshield. It was one of those vehicles synonymous with the Southwest, which had been sanded down and

repainted so many times, that its surface had been transformed into an abstract canvas.

"I'm Bernadette Track," she smiled. "I used to model for the painter R.C. Gorman" (initially a serious Navajo figurative artist whose work crossed over to the tourist trade). In an attempt to convince me she was telling the truth, Bernadette made a palms-up gesture with one hand and turned her head to the side, as if she was posing for Gorman. Though she was clearly well into her sixties, she still "had it going on."

"You really do resemble the women in his paintings," I said.

"That's because I was one of them," she grinned. "Listen, maybe you can help me out. I came to see Phillip to see if he'd buy a painting from me. But since he's not here, maybe you'd like to buy it?"

"Let's have a look," I said.

Bernadette went to the back of her truck and produced a rolled up canvas. When she unfurled it, the painting measured five by three feet. Its background was painted with alternating raspberry and purple horizontal stripes which resembled a Navajo rug. In the foreground were six Hopi maidens. Each had her hair fashioned into a pair of traditional buns on the side of her head. All in all, it was a decent painting.

"Would you give me a hundred dollars for it?" she asked.

I shrugged. Before I could say anything, she interrupted, "How about fifty? I need to fill my tank with gas—the truck is almost empty."

I believed her and I liked the painting well enough to give her fifty dollars for it. I reached into my wallet and handed her the cash.

"Great," she said, "I really appreciate it."

"Hey, so do I—I'll look forward to finding a place for it in my home."

Bernadette drove off, presumably to buy gas. Moments later, Phillip Reyna pulled up.

"Hey Richard, how's it going?"

"Good to see you Phillip. Check out what I just bought from Bernadette Track. I think she was hoping to sell it to you."

He smiled, "I'm glad you bought it—I'm sure she needed the money."

We entered his shop, which was crammed with objects. Much of it was part of the family's collection and was not for sale. There were kachina

dolls, lots of pottery, a few Yei rugs, and a nice assortment of turquoise and silver jewelry, some of it by Phillip himself. I sensed much of the merchandise had sat idle for years—maybe even decades.

"Hey, I've got something for you," said Phillip.

Phillip and I had gotten into the habit of exchanging small gifts. Previously, I had given him a black buffalo hide belt and he had bestowed upon me a small kachina. That day, he produced a tiny Zuni bear fetish, carved from pink onyx, that was the size of a nickel.

"Thanks," I said. "Do you think you could bless it for me?"

A fetish's mojo can only be activated by a medicine man's blessing. Otherwise, it's only a handsome talisman. I knew Phillip wasn't a medicine man. But I was also aware that he participated in the sacred dances at the Pueblo.

"Okay, I guess I can do that," he said.

Phillip held the fetish in his hand, closed his eyes, and prayed in silence for about twenty seconds. Then he returned it to me and I placed it in my pocket. The thing about spirituality is that if you believe there's a force out there—whether symbolized by a Deer Dance or a fetish—it becomes powerful medicine that permeates your life.

14

MERCURY DIMES

I took a close look at a painting hanging at Stephen's Consignments in Santa Fe. The signature read Nocona Burgess. It was a small canvas, with a few Mercury dimes curiously collaged onto its surface. The tarnished silver coins were a reference to the Nez Perce rodeo king, Jackson Sundown, the first full-blooded American Indian to win the World Bronco Riding Championship in 1912. Legend has it that Sundown claimed to be such a great rider, he bet a fellow cowboy that if he placed a handful of dimes under the saddle of a bucking bronco, none of them would fall out. He hopped on his saddle, his horse was turned loose, and sure enough not a single dime was dislodged. Nocona's painting was a powerful reminder to his people that Americans Indians penetrated all aspects of American life. All you had to do was look.

I met Nocona for the first time at a Native American art show at the Santa Fe Community Convention Center. His booth was covered from top to bottom with recent paintings. When we spoke, he eagerly shared his colorful background, "I'm a Comanche, originally from Oklahoma, and I'm also the great-great grandson of Chief Quanah Parker." To those not familiar with the legend of Quanah Parker, he was the last chief of the Comanche, and the son of Chief Peta Nocona and Cynthia Ann Parker. Cynthia, who was white, was abducted as a young child by the Comanches and raised by their tribe. Twenty-four years later, she and her daughter were liberated and reunited with her Anglo family. But by then, she was a fully-assimilated Comanche and was unable to transition back to her earlier life.

All of Nocona's paintings honor his ancestors and other significant Native Americans. Visually, his portraits are distinguished by how each historic figure is placed in front of a simple contemporary geometric design; sort of a past meets present. This component of his imagery calls to mind the early minimalist canvases of the abstract painter Frank Stella. As for the figures themselves, their faces are painted in black and white, creating striking contrasts that are almost three-dimensional.

We made some small talk and then Nocona described a recent trip, "I just returned from a show in London. Almost everything sold—nineteen out of twenty-one paintings."

Nocona pointed out that his work also did well in Santa Fe. But his European experience confirmed something I had repeatedly heard about how Native American artists are often treated with greater respect when they show in Europe or Japan than in the United States. It reminded me a little of the state of the jazz world during the 1960s, when American musicians struggled to find an audience beyond Greenwich Village, but were welcomed as royalty when they played Paris, Copenhagen, and Helsinki. Echoing America's relationship with indigenous artists, it was a classic case of not fully appreciating what we have in our own backyard.

There's also a group of dedicated American art collectors who pursue Native imagery that's not painted by Native artists. The paintings that depict Native Americans and bring the most money are by an eighty-eight year-old Anglo who lives in Tucson named Howard Terpning. Over a long successful career, Terpning has attracted a group of loyal buyers who can't seem to get enough of his work. Nowhere is that more in evidence than with their voracious support of his art at auction. Having seen three of his paintings appear at the annual Coeur d'Alene Art Auction in 2018, I watched in amazement as two major examples were knocked down for five hundred and seventy thousand dollars, respectively, while the third broke a million. To put this figure in perspective, Fritz Scholder's auction record at the time was a mere forty-eight thousand.

The artist's following stems from his ability to render American Indians the "way we like them." They are portrayed in elaborate war parties, divvying up buffalo meat after a kill, and on horseback fording a fast-moving stream. Terpning's iconography connects collectors to

the romantic Wild West that they want to believe really existed. But the paintings strike a false note. While many tribes lived well, they did not lead an idyllic existence; most were too busy with survival. The other issue is Terpning's technique. Though he's a strong draftsman and knows how to create a sense of pictorial drama, his paintings are garish. Terpning has a tendency to drench his figures in colors which lack nuance or subtlety.

When I mentioned his work to a number of well-known Native American painters, none had heard of Howard Terpning. It's as if there's an alternate universe out there, a strange dichotomy of paintings created by Anglos of American Indians, and by American Indians of American Indians. Yet, pictures by Anglo artists like Howard Terpning, Martin Grelle, John Moyers, and Logan Maxwell Hagege routinely sell for more than those painted by their Native counterparts. The reason why is because their art is bought by Anglo collectors who want American Indians to look like they just stepped out of a John Ford Western; they want to buy "Hollywood Indians." Anglo collectors dictate the market because, as far as I know, few Native Americans collect serious American Indian art. It's a vicious cycle, leading American Indians to paint for their collector base, rather than themselves.

Once again, I thought about Fritz Scholder, and how he struggled to find his equilibrium between painting for himself and the demanding Anglo market. Seeking another perspective on the subject, I gave Kevin Red Star a call. From what I had read in a recent monograph titled *Kevin Red Star*, by Daniel Gibson and Kitty Leaken, he was able to find that balance. The Crow painter was old enough to have studied with Scholder at the IAIA. My first exposure to his work took place at a shop owned by the veteran jewelry designer David Dear. His walls were covered with paintings that appeared to have been equally influenced by Scholder and T. C. Cannon.

I asked Dear to identify the artist. He looked incredulous, "You don't know Kevin Red Star?"

"No, I don't," I said. "They look a little like Fritz Scholder…"

Dear acted offended, "What are you talking about? He's much better than Fritz."

Kevin Red Star's portraits of Native Americans are easy to recognize,

with their slight hint at caricature, and skinny vertical lines of black war paint which run down the faces of his subjects. The effect is more friendly than frightening. His palette tends to favor deep reds, ochres, and blues. But what stands out about the work is its spirit; Kevin's love for his fellow Crow brothers and sisters comes through loud and clear.

I called Kevin Red Star. He was busy painting in his Montana studio but graciously took time out to answer a few questions. I asked him about his years as a student, when Scholder was one of his instructors. Whenever I brought up the name Scholder, I noticed a consistent pattern of responses among living Native artists. Everyone acknowledged his importance for breaking the ice. But I have yet to meet an artist who admitted Scholder had an impact on his work. It was as if Scholder's art was so all-encompassing, that rather than accept that everyone is indebted to him (this writer's opinion), artists elected to escape his long shadow by ignoring it. Kevin Red Star was no different. Choosing his words carefully, he responded, "Scholder wasn't really an influence. But those were good days at the school."

"Did you know Cannon?"

"Oh, sure. I was good friends with T.C.—the Crows and the Kiowas always got along," said Kevin, with pride.

I asked him how he felt about Scholder's tendency to take periodic breaks from painting American Indians, in order to recharge his batteries. Kevin responded, "I've gone through the same thing. From time to time, I quit painting Indians and paint female nudes."

"How does that affect your sales?"

"It doesn't," said Kevin. "A lot of sales take place directly at the studio. My collectors are always stopping by to visit and if they respond to a nude—they buy it. They seem less concerned with subject matter than buying whatever I'm currently doing."

I said, "You're very fortunate."

I asked Kevin if he was familiar with Tony Abeyta and Diego Romero. "Those young guys are great," he said with enthusiasm. "They're the ones keeping the art alive."

I agreed, but said, "Tony just turned fifty. They're not so young anymore."

Kevin laughed, "Hey, when you're over seventy they are."

After my phone call with Kevin, I decided to head over to the Downtown Subscription, for a quick cappuccino. After placing my order, I bought a copy of the *Santa Fe New Mexican*. It was filled with the usual fare of a heroin bust in Espanola, a smattering of DUIs, and reports of police heavy-handedness in Albuquerque. Since it was Friday, these dark tales were counterbalanced by the always entertaining arts magazine *Pasatiempo*, which was included as a free insert. Another strength of the *Santa Fe New Mexican* was its ability to predict the weather, which was useful given its tendency to morph by the hour.

However, today there was some real news. The front page featured a color photograph of the celebrity chef Anthony Bourdain. The headlines screamed bloody murder; the author of *Kitchen Confidential* had dissed the downtown Five & Dime's fabled Frito pie. This was no minor slight. You could insult just about anything in Santa Fe, but you never bad-mouthed its Frito pie.

For those unfamiliar with the local delicacy, a Frito pie is prepared by taking a small foil bag of Fritos, cutting it open horizontally with a pair of scissors, pouring hot chili on the nest of corn chips, and topping it off with a blizzard of shredded cheese. The heat from the chile melts the cheese, transforming the gooey concoction into a tasty treat. Though I've been told the Frito pie originated in Texas, the home base of the Frito-Lay Corporation, Santa Fe somehow hijacked the snack and now claimed it as its own.

Bourdain, who was in town filming a television segment of *Parts Unknown,* made the fatal mistake of going on camera and revealing, "It feels like you're holding a warm crap in a bag." That was bad enough. But he crossed the line by inaccurately claiming the Santa Fe version was made from "canned Hormel chile and a day-glow orange cheese-like substance." This was too much for the locals, who called for Bourdain's head. Earl Potter, the owner of the Five & Dime, demanded a public apology. Miraculously, he got one. Bourdain's handlers issued a statement saying despite the alleged insult, he actually enjoyed every bite. The town's fathers were mollified. Apparently the controversy didn't hurt business, either. Potter concluded, "So far, we've had our best month ever."

15

ALBUQUERQUE AND CLEVELAND

I decided to drive to Albuquerque. It's only sixty-four miles from Santa Fe, yet psychologically it might as well be in another state. It's New Mexico's most populous city, has a much more diversified economy than Santa Fe, and is far less touristy. Yet, you'll also find a plethora of New Mexican history, art, and some pretty terrific food. After driving approximately forty-five miles, the city began to sneak up on me. Their version of urban sprawl is more like "urban amoeba." Not until I traveled another fifteen miles did I enter the real Albuquerque.

I exited and began a slow crawl down Central Avenue, part of the old Route 66, which remains the main drag that runs through the downtown. Along the way, I passed a number of streets named after metallic minerals, including Lead, Gold, Iron, and Silver. Soon, I came to Skip Maisel's Indian Jewelry. In business since the 1930s, it's distinguished by a façade decorated with period frescoes commissioned from local Pueblo Indian artists—including Tony Abeyta's father Narciso. Each panel depicts a different ceremonial dance, including a Yeibechei and a Deer dance. The paintings' surfaces have weathered over the years, yet their faded colors remain richly expressive. It's surprising that these amazing frescoes haven't received landmark status from Albuquerque's historic preservation committee.

During Maisel's heyday, in the 1940s and 1950s, you could walk in and watch up to three hundred Navajo craftspeople create their art. The large store was designed with a cutaway view of its basement workshop. When one peers over the banister that rings it, you're afforded a bird's eye

view of the silversmiths cutting, welding, and pounding out their jewelry. These days, there's only a token artisan or two on display. Maisel's other unusual feature is a terrazzo floor at the entrance embedded with Mexican silver dollars.

When I walked into Maisel's, I was overwhelmed by the sheer number of objects for sale. There were hundreds of kachina dolls, paintings, and drums, along with thousands of bracelets, rings, and necklaces. In the old days, the shop's substantial inventory retained a distinctive hand-made quality. Though everything is still fabricated by local American Indians, something was missing. The other disconcerting thing about Maisel's is how their aging employees project a bored vibe. When you asked them a question, or requested to see something in a case, they acted disinterested. You sensed the shop was on life support and just waiting for someone to pull the plug. It finally closed in 2019.

I stepped out of Maisel's and spied the newly restored KiMo Theatre, an Art Deco/Pueblo Revival architectural gem. Soon, I came upon a pawnshop called Old Town Jewelry and Loan Company, and decided to check it out. Unlike much of this genre, the store's interior was bright and the mood was friendly. There was a prominent sign stating they only pawned jewelry and guns. In fact, there was a short line of patrons holding rifles. More pertinent to my interests, the walls were ringed with inexpensive paintings by the local Navajo artist Fred Cleveland. A typical Cleveland was painted in "straight from the tube" colors and illustrated Indians "doing what we expect Indians to do"—hunting, dancing, and making jewelry. They had a naïve quality about them; it was obvious he was self-taught. Cleveland was one of those mysterious figures who no one seemed to know much about. You rarely saw more than one painting at a time. But that day, I discovered the mother lode.

I said to one of the employees, "So Fred Cleveland actually does exist?"

"Of course he does—he was just in the other day."

"What's he like?"

The man chuckled, "He's middle-aged...a bit of a character...and he certainly works fast."

I pointed at a framed canvas that caught my eye, depicting three men

dressed as Mud Head kachinas, and asked, "How much do you want for it?"

The employee walked up to the picture and shook his head, "Sorry, it was three hundred, but it's on layaway."

"What do you mean? You sell three hundred dollar paintings on time payments?" The moment the words left my mouth, I felt like a snob, and regretted saying them.

"We have a lot of low-income customers and we're happy to help them out. We're letting the couple who bought the Cleveland pay it off over six months—fifty dollars a month." I nodded, impressed by how much the art must have meant to the buyers.

§

Once I was back in Santa Fe, I recalled my promise to Frank Buffalo Hyde, a self-described Native Pop artist, that we would get together so I could check out his work. His paintings combine Indian stereotypical icons with images culled from everyday life. For instance, he'll paint a buffalo with its massive head and slender legs protruding from a hamburger on a bun, loaded with all the fixings, against a bright blue and pink polka dot backdrop.

Speaking with Frank, I asked, "You probably get this all of the time, but is that your real name?"

By the look on his face, he had indeed been asked this question more times than he cared to remember, "Yes, it is. The name Buffalo comes from my great-grandmother who was a member of the Nez Perce tribe. And my last name belongs to my dad, the sculptor Doug Hyde." Doug Hyde is known for his large stone carvings. One of his finest can be seen on the grounds of the State capital in Santa Fe. Doug Hyde also creates figurative bronze sculpture and even casts traditional Native American ceramic pots in bronze—something I had never seen before.

I asked Frank about his career and whether he cared about breaking out of the Native American art scene in Santa Fe. "Sure, I want to see my work get beyond Santa Fe. I care about the big picture and I'm interested in

exhibiting in New York—and believe it will happen. But in the meantime, my work is selling and I have good representation."

I liked Frank Buffalo Hyde's confidence. I began to survey the work of his Native peers whose imagery also crossed into Pop, including David Bradley. His brand of realism, populated with stylized figures, focuses on popular culture. A good example is Bradley's commentary on the iconic Land O' Lakes butter package, with its beautiful but stereotypical American Indian maiden on the box. He also painted the Lone Ranger and Tonto, Georgia O'Keeffe in her studio, and a version of the famous Henri Rousseau painting, *The Sleeping Gypsy*. In the latter, Bradley replaced the African lion with a puma, and a snoozing female American Indian was substituted for the sleeping lady gypsy.

Both Hyde and Bradley represent a crowded position in contemporary Native art that filters popular culture through Native American irony. Yet, there was still plenty of room for more traditional artists like the Flagstaff painter Baje Whitethorne, whose work's spiritual content stayed with me ever since the day I wandered into Lone Dog NoiseCat.

The public associates Native art with spirituality. However, appearances can be deceiving. A painting of an ethereal looking Native woman wearing a white deerskin dress with her hands outstretched to the sky, while an eagle soars above, is only spiritual when executed by an artist with legitimate skill—who also leads an authentic life. Not to get too deep or philosophical, but most American Indian artists are painfully aware of the market for their work. It's literally impossible to create art that transcends decoration with one eye on the marketplace. Put another way, you can't make great art that encourages the viewer to connect with something that resonates deeper, when you're worried about whether it will sell.

Sensing the need to get out of Dodge for a while, I decided to drive to Flagstaff to seek out more of Baje's work, and hopefully meet the man himself. Though "Flag" was approximately 380 miles west of Santa Fe, and I could easily make the drive in half-a-day. Needing a break, I thought I'd stop in Gallup. I had always been curious about the Zuni fetish makers who resided near the city. While living in Santa Fe, I picked up a natural turquoise frog fetish. I enjoyed its visual quality, but I enjoyed the stories

even more about how American Indians sometimes buried them along streams to encourage rain.

Unfortunately, much of the work was kitsch. Some fetishes even had plastic eyeballs glued to them. But the great carvings, by masters such as Leekya Deyuse, had personalities. They had a life force to them. Unlike the various bears, badgers, mountain lions, moles, and frogs—the "big five" of fetishes—their compact size allow you to comfortably put one in your pocket and carry it with you everywhere you go. Whenever I fish my frog fetish out of my jeans, and hold it in the palm of my hand, it brings a smile to my face and a sense of gratitude. I felt like it was time to try to meet the artisans who created these tiny objects which inspire such outsize emotions.

...

16

THE FETISH KING

The three-hour drive from Santa Fe to Gallup is spectacular once you get beyond Albuquerque. You pass gnarly dark brown lava beds laid down eons ago, a scene so primeval you wouldn't be surprised to see a Stegosaurus lumbering about. The volcanic rock eventually gives way to sandstone mesas in the distance, whose multi-color strata of ochre, terra cotta, and plum resemble a torte frosted with crushed pistachios—reminiscent of Scholder's early landscape paintings. But once the topping comes into focus, you discover it's only pinion pines. While driving, I continued to spot long necklaces of freight trains, flanking the road. I passed an eighteen-wheeler with the trucking line "Navajo" stenciled on its side. Gone was the iconic portrait of a proud American Indian chief, its banishment chalked up to our growing awareness of racial injustice.

Once I hit the turnoff to Gallup, I drove through its business district. The first thing I noticed was a banner strung across an intersection which proclaimed, "Gallup: America's Most Patriotic Small Town." The city is home to a large number of Navajo veterans. I quickly passed the block-long Richardson Trading Company, with its old red neon sign and picture windows jammed with every conceivable American Indian art form, sun-faded rugs, and even a football-size turquoise nugget. Moments later, I registered for a room at the El Rancho. It was once a favorite of visiting movie stars, who made films in the area during the 1930s and 1940s. The cavernous two-story lobby has atmosphere to spare. It was constructed from dark-stained wood, and lined with Western paintings, along with Indian rugs draped over the balconies, floors, and every other bare surface that the decorator could find.

With lodging secured, I headed back downtown to check out Bill Malone Trading. I had recently read a book called *The Case of the Indian Trader* by Paul D. Berkowitz. It chronicled the recent era when Bill Malone ran the historic Hubbell Trading Post, in Ganado, Arizona—until he was removed from his job by the National Park Service, after being accused of cheating them and the Navajos he served. Despite the absurd charge, the case took an ominous turn when the FBI was called in to handle the investigation. Malone's substantial personal collection of American Indian rugs and jewelry were confiscated. Adding to his predicament, the government kept him in limbo about his status for four years, neither finding him innocent or guilty. Finally, after the National Park Service virtually destroyed his life, he was exonerated. Malone countersued the government, receiving a settlement, which helped him open his shop in Gallup.

What Washington could never grasp is that traditional trading posts are not conventional businesses. They still operate with a pre-computer mentality. Record keeping is done on slips of paper, with trades written down by hand. Sometimes the trading post comes out a little ahead, sometimes the customer does. But it all works out in the end. From what I was told, the only thing Malone was guilty of was giving the occasional free can of soda to an American Indian child while his parents shopped. Malone, who is married to a Navajo woman and is fluent in the tribe's complex language, earned a reputation for having the Indians' best interests at heart. There were countless times he bought rugs and jewelry from artists, even when he was overstocked. He not only embraced the Navajo people, but he was one of them.

I walked into Bill Malone Trading and introduced myself to Bill, "I read that book about you—the government was completely clueless."

Malone, who appeared to be in his seventies, with white hair peeking out from his cowboy hat, smiled, "Yeah, I'm sure glad that's over with."

"Did you get your collection back?"

"Yes, but I can't get back the years they took from me."

Noticing all of the beautiful textiles on display, I asked, "Can I see the rest of your Navajo rugs?"

I followed Malone, trailed by a shy Yorkshire Terrier rescue dog. The

"wool" was stacked on a sofa in large piles. I began peeling rugs away, one at time. Soon, I came upon a group of "Gallup Throws" woven during the 1970s. While sorting through the rugs, a song by the Eagles, also from the seventies, was playing on the radio. These weavings were designed with simple zigzag patterns, often in deep earth tones. Most standard Gallup Throws measure around 20" x 40" and were sometimes sold by the pound to dealers; hence their nickname, "Pound Rugs." They were also derisively called "Whiskey Rugs," because some weavers would trade a rug for a bottle of hooch, the minute it was finished.

I found a contemporary version of a Gallup Throw with an alternating pattern of yellow-gold and black ovals, resembling clouds against the horizon. I asked Malone, "How much is this?"

He replied, "That's a good one—it's hand-carded and woven from homespun wool. Very few rugs are still made this way. I should probably keep it. But you can't keep everything. Since we wholesale our rugs, you're looking at only a hundred and fifty."

"I'll take it," I said without hesitation. It was one of the better bargains I came across in the Southwest.

After I left Bill Malone's, I went over to Don Diego's Restaurant for a plate of chicken fajitas. Their version rivaled anything I tasted in Santa Fe. While waiting for my order to arrive, I noticed several American Indian vendors going from table to table offering inexpensive jewelry and crafts. I asked my waitress, "What's up with that?"

She replied, "There's so much poverty around here that local business owners look the other way—as long as they're not too aggressive with the customers."

A teenage girl approached my table, "Would you like to buy this piece of pottery—I painted it myself and it's only forty dollars."

As a courtesy, I picked it up and examined it, "I like your work but I can't spend any more money today."

With a look of disappointment on her face, she said, "How about thirty?"

"Sorry."

"Tell you what. I've had a good day—I'll give it to you for only twenty."

With Bill Malone's generous spirit still fresh in my mind, I said, "You're a good artist. I'll tell you what—I'll give you twenty-five for it. Thirty seconds later, I was the proud possessor of a new clay pot. The experience made me reflect on the hard lives that many of Gallup's Navajo artists and craftspeople still lead.

After finishing dinner, I walked around the downtown for a bit and then returned to my car. I was about to call it a night when I heard some melodic flute music in the distance. I got out of my car and took off on foot, trailing the music to its source. There was a large gathering at the Gallup Courthouse Square. A security person explained to me that during the summer months the city hosts an Indian dance every night.

That evening we were treated to a performance by members of the Oglala Sioux from South Dakota. The drummer pounded out a fast beat and sang while his partner performed a Hoop Dance. Moments earlier, he had laid out five white wooden hoops on the ground, each half the size of a Hula Hoop. While whirling around he used his foot to deftly pick up an individual hoop. As the dance progressed, he added additional rings, one at a time, until he was working with all five. While the dancer continued to spin, the hoops gave the illusion of shapeshifting from a bird to a butterfly to a coyote. As darkness descended, the light grew hazy, and the dance grew more mesmerizing.

§

When I woke up the next morning in Gallup, I looked a map and realized I was only thirty minutes away from the Zuni pueblo. The Zuni are known for their intricate inlay jewelry designs, often featuring the mythical Rainbow Man and Knifewing figures. They also have a reputation for producing outstanding needlepoint bracelets with dozens of tiny polished turquoise cabochons set in silver. In addition to their prowess as silversmiths, the Zuni people are master carvers of stone fetishes. Much like African masks, generations ago fetishes were utilitarian; they were fabricated strictly for ceremonial use. The identity of the individual who

created them was irrelevant; there was no such thing as an artist. Now, just like African carvings, fetishes are traded as works of art—and signed by the artisan.

I was told if I visited the Zuni pueblo, I could buy them directly from the artists. I drove thirty miles south of Gallup, arrived at the Zuni reservation, and pulled into the parking lot of a convenience store. I had barely made it out of the car when a short man carrying a cigar box approached me. I thought, I must have the word "TOURIST" stenciled on my forehead. Then again, I obviously stood out, in my Bailey cowboy hat and Lucchese boots.

"Mister, do you want to buy some fetishes?"

"You're just the guy I want to talk to," I smiled. "Let's see what you got."

The artist was clearly taken aback by my enthusiasm. Inside his box were six fetishes; two parrots, two coyotes, a fox, and a badger. They were sculpted from a colorful local rock called pipestone, known for its bands of caramel, cream, and mocha. The fetishes were deceptively simple and measured no more than two inches long.

As I examined each creature in the palm of my hand, I asked, "How much is this one?" The answers ranged from twelve to twenty-two dollars, which I was told were wholesale prices. I selected the pair of parrots and was quoted fifteen dollars each. But if I bought them both, he'd take twenty-five. Done.

The next thing I knew, several others fetish carvers spotted what was going on, and descended upon me. I couldn't resist buying a couple pieces from each of them. My pockets bulged with tiny sculptures, as I began a short trek on foot into town. Soon I passed a small stone house with a pretty Zuni woman out front doing some gardening. She waved to me and shouted out, "Are you from around here?"

"No, I'm just visiting from Santa Fe," I said, flattered by her friendliness. She approached me and introduced herself, "I'm Joni." We spoke for ten minutes about "rez life" and how she rarely left the pueblo. As we grew more comfortable talking, I said, "I'd really like to visit a fetish carver's studio."

"Studio?"

"You know...their workshop. Do you know anyone who might let me come over?"

She whipped out her cell phone, reached the intended party, and spoke to him in Zuni. For some reason the conversation grew animated. Joni hung up, "Okay, let's go visit my cousin Elroy. He lives only a few blocks from here."

We walked past row after row of dilapidated brown houses with barren yards. No grass, no shrubs, and no trees. We continued our walk through a labyrinth of shacks. I grew a bit concerned over whether I was being set-up to be robbed. Those feelings increased exponentially once we came to a hovel with its tarpaper roof peeling off. Joni knocked on the door, but there was no response. Then she yelled something in Zuni, the door opened a crack, and we were waved in. The only light source was a single smudged window. The floor was made of packed earth. A round woven rug was haphazardly thrown on top. A pyramid of crushed beer cans littered one corner. The sheetrock ceiling was water-stained. It sagged in the center and appeared to be on the verge of collapse. But it was the main wall, or should I say what covered it, that got my attention. It was carefully hung with Playboy bunny centerfolds. The foldouts were clean and evenly spaced. The incongruity of it all was disorienting.

Joni made introductions. One of the thirty-something men stuck out his hand, while his friends passed a bag of potato chips back and forth.

"I'm Elroy. Let me show my fetishes."

A member of his posse finished off the chips, crushed the bag, and casually tossed it in the corner, topping the beer cans like a snow-capped mountain. I walked over to Elroy's workbench. It held a grinding wheel and a polishing wheel. There were also a few scattered carving tools, broken pieces of rock, and bits of red coral branches. Amongst all this detritus were three gorgeous fetishes; two bears and a miniscule frog. They were expertly carved in beautiful minerals. The frog was particularly intriguing. It was made of natural turquoise—possibly Kingman—with inlaid red coral eyes.

Elroy then spoke, "Today's a feast day at the pueblo and I really shouldn't be doing any business." His compadres nodded solemnly. Then Joni started arguing with him in Zuni. They may have been relatives but their relationship was contentious.

"Look," I said. "I don't want to do anything that goes against your religion…"

Joni jumped in, "Don't worry about it—it's fine. Our beliefs teach us to help ourselves."

A consensus was reached; the fetishes could be sold. Elroy said he wanted a hundred twenty for the group of three carvings. They were expensive but clearly worth it. His work was superior to what I had seen at the shops in Santa Fe. We settled on a hundred dollar bill for the group. Once the money changed hands, Joni and Elroy began quarreling again in Zuni. Apparently, she expected a commission. I gave her a twenty dollar bill, just to keep the peace. With hugs all around, I departed, thrilled with my new acquisitions.

§

I drove back to Gallup, contemplating the strange and fascinating experience I just had. I thought about enlisting a medicine man to bless my frog so I could bury it by a stream, just as previous generations of Zunis did. The region sorely needed the rain. But as I glanced at the "sky stone" amphibian, nestled on the passenger seat, I couldn't bring myself to cover it with earth and hide it from the world. I had become a typical tourist who treated a fetish like a work of art, rather than an object created as a conduit to the gods. I didn't want to admit it, but something had been lost in the translation.

17

GALLUP

It was noon and I was still in Gallup when it occurred to me that it was Saturday—also known as "flea market day." The Gallup Flea Market has a well-earned reputation for being the most interesting and diverse in the state of New Mexico. Since Gallup is known as the "Gateway to the Navajo Nation," its vendors are predominantly Native American and sell wares related to their culture. It's also a regional food paradise. Tony Abeyta, who grew up in the area, often boasted about its delicious edibles—especially the mutton sandwiches.

Before I got on the road, I looked on in astonishment as gunmetal gray rain clouds scudded in. Rolling thunder made its presence felt. Within moments the clouds reached critical mass. They turned a malevolent purple black that was so dark that it hurt to look at them. In an instant, rain drops the size of silver dollars detonated upon impact with the pavement. I waited for the storm to spend itself. Almost as quickly as it started, it was over. That is the thing about summer monsoons in New Mexico; they're intense but brief.

Once the storm moved on, I found the dirt road which led to the flea market. Its muddy but hard-packed clay aisles were crammed with perhaps seventy-five tables, displaying everything from petrified wood to fetishes, pottery, blankets, and rugs. A dizzying array of American Indian jewelry varied from costume pieces to genuine old pawn. The one incongruent element was a booth with pets for sale: cages packed with rabbits, parakeets, and puppies.

Before long, I found the vendor with mutton sandwiches. Someone

waiting in line explained to me that mutton referred to meat from an older sheep. Though a bit on the fatty side, it was flavorful and left me craving more. The flea market also sold Navajo burgers; a hamburger patty, lettuce, tomato, and mayo on two pieces of frybread. A Navajo staple, frybread is a flat piece of dough made from wheat flour, sugar, and salt. Then it's deep fried in oil or lard—which gives it a puffy texture. It's often enjoyed with honey on top.

As I continued to stroll, I found a table with a framed ceramic tile, maybe six-inches square, depicting a kachina dancer in full regalia. The isolated figure was glazed in a nice array of earth tones against a background of cobalt blue. During the 1970s, there was a factory in Santa Fe called Territorial Tiles which produced high-quality hand-painted ceramic squares featuring Native icons. Sure enough, when I turned over the back of the tile, it was signed and stamped by that workshop. Amazingly, even though the original wooden frame showed some wear, the actual tile wasn't chipped or scratched.

I spoke to the young guy manning the table, "This is really wonderful. What do you want for it?"

"How about ten bucks?"

I was stunned; it would have been at least seventy-five dollars in Santa Fe. All I could say was, "Sounds good to me," as I reached for my wallet.

Since I was on a roll, I asked, "Do you have any more?"

"Sorry," said the young person, "We just cleaned out a house and it was the only one we found."

With my newspaper-wrapped purchase in hand, I walked away filled with bliss. Sometimes it really is the small victories in life that make you happy.

One of the surprises of the Gallup Flea Market were all of the contemporary Native American painters who exhibited their work. For the price of a booth, which I assume was under fifty dollars, an artist could literally have a one-person show. While I had no idea what sort of audience patronized the flea market, it probably attracted at least some affluent tourists, based on its long-established reputation. I assume they were the buyers who kept these intrepid souls afloat.

As I made the rounds, I came upon a Navajo painter named Milton John. His space was hung salon style with modest-size canvases. The best ones featured clusters of Yeis, grouped tightly like a bouquet of flowers. Deep reds, browns, and greens dominated his palette. The work had a certain economy to it that spoke of trying to get the job done between nine and five. Whatever the case, these paintings rocked.

I greeted Milton John, "Nice work. Do you have a gallery that handles your art?"

Milton, who was tall and slender with long dark hair, and appeared to be in his mid-thirties, responded, "No, I represent myself."

Pointing to a pair of colorful twelve by ten-inch pictures, I said, "These are really exceptional. How are they priced?"

"Thirty dollars each."

At first, I thought he was kidding. The canvas and paint alone must have cost him that much. I quickly spotted a slightly larger one.

"What about this picture?"

"Forty dollars."

"Great," I said, handing him two twenties.

To put things in perspective, I had just purchased a painting that was probably better than eighty percent of what I saw on Canyon Road, for the price of lunch (for one) at the street's famous Compound restaurant.

As I got in the car, and began driving toward Flagstaff, it occurred to me that New Mexico was filled with talented Native American artists who functioned off the art world grid. Basically, they were one-person operations. The artist made the art, promoted it, and sold it. Gallery representation was irrelevant. What mattered was selling enough paintings to keep going. It made me fantasize about assembling a stable of unheralded American Indian artists like Milton John and opening a small storefront gallery in Santa Fe to show their paintings. But as I crossed the Arizona state line, which still had a large sign up commemorating their centennial anniversary of becoming a state in 1912, my thinking eventually came full circle. The reason these artists were in this precarious position to begin with was because of the sad fact that there weren't enough collectors to buy their work.

§

Before I left Gallup for Flagstaff, I thought about the Fritz Scholder I once owned, *Indian at Gallup Bus Depot*. Though the picture was painted in 1969, I wondered whether the actual bus depot was still around. I thought it might be cool to experience what Fritz saw. Was the arcade game, which the figure in the painting was leaning against, still there? Was it still patronized by American Indians who dressed as cowboys? But I realized that even if I found the bus station, it would be a depressing reminder that I never should have sold the painting.

The drive to Flagstaff took just under three hours. It was already dinnertime, so I stopped at a downtown restaurant called Cirollo Latin Kitchen. When I walked in, I had one of those moments that convince you that your life is on the right path; the walls were lined with paintings by none other than Baje Whitethorne.

18

A GOOD KACHINA

The next morning, after a scrumptious chocolate croissant at Macy's European Coffeehouse & Bakery, Baje Whitethorne welcomed me into his home. It was filled with Native American works of art that he had collected over the years, mostly by friends and colleagues. Baje's petite wife, Priscilla, waved us into the kitchen where I was treated to a piece of frybread with wild honey. The scene turned chaotic as their four-year-old granddaughter, Memphis, insisted on showing me her new toys. Baje's son, who goes by Baje Jr., and is also an artist, strolled in. When his dad mentioned that I wrote about art, he immediately suggested that I take a look at what he was up to—his workshop was next to his father's. Then, in the middle of it all, the doorbell rang. It was a film crew, who began setting up cameras to interview Baje Sr. for a documentary about artists of the Southwest.

I said to Baje Sr., "Can we go to your studio before things get any crazier?"

"Sure," he replied, smiling.

Once we were inside his atelier, he showed me five or six paintings in various stages of completion. I spotted a small horizontal one, leaning against the wall, peering out like a fugitive. I pulled it out for closer inspection; the picture's narrative brought Baje's storytelling skills into high relief. It revealed a boy, from the shoulders up, protruding from a hole in the ground. Alas, his hiding place had been discovered. Above him stood two scary Yei gods, their costumed forms casting ominous shadows. The boy's mouth was open and he was yelling at the deities to leave him alone and not abduct him. Apparently, the youngster was a truant. When Baje

was a child, his grandmother told him this story whenever he complained about not wanting to go to school: "If you don't go, the monsters will get you."

Somehow, we cobbled together a deal for the painting, a combination of cash and trade. Baje gave me a generous amount of credit for a vintage Navajo silver belt buckle, a turquoise bracelet, and a pair of silver collar tips. He handed the sandcast buckle to his son, as he uttered, "Happy birthday." Baje Jr. grinned and immediately put on his present, whose center contained a highly-polished piece of orange spiny oyster shell. I was equally anxious to start enjoying my new acquisition; I couldn't wait to get it home.

We sat down on the sofa as Baje brought me up to speed on how he became an artist. In many ways, he owes his career to a curveball life threw him. As a young man in 1975, he was working as a boilermaker when he was seriously injured on the job. Laid up for almost a year and a half, Baje thought about his future and couldn't envision returning to his old position. Instead, he began to wonder what else he could do with his hands. Eventually, he remembered how much he enjoyed art as a youngster. He picked up a brush, one thing led to another, and he discovered his true calling.

Now that we had the preliminaries out of the way, we got into a discussion about his work and the state of the Native American art market. We also talked about the children's books he wrote and illustrated with charming watercolors—a little-known facet of his oeuvre. Mention was also made of his cast bronze figurative sculptures, yet another overlooked aspect of his body of work. My last question to Baje was one that I had asked every Native American artist I met, "Do you care about being part of the New York art scene?"

Baje needed little time to respond, "I'm not worried about showing in New York because the work manages to get out there. I've been doing this for a long time and have sold a lot of paintings over the years. Whenever a picture of mine ends up in someone's home, additional people see it, and some of them become new collectors of my work. So the exposure my paintings receive keeps multiplying. Another thing is I never worry about is what to paint; I paint what I want to regardless of what New York is looking for."

§

Baje's indifference toward careerism was refreshing. But sometimes New York comes to you. And it may be coming to Cara Romero. She is uniquely positioned to become the first Native artist since Scholder to break through to the "serious" art market. Her work is inspired by traditional Native rituals and iconography, but its contemporary format is in tune with the international art world. Cara Romero's photographs would feel at home in Gagosian, arguably New York's most prestigious gallery.

Tony Abeyta told me he had just bought Cara's newest piece, *Water Memory*. It measured some three by three feet and was printed in a limited edition of only six.

"It's her 'Moonrise,'" said Tony, referring to Ansel Adams's iconic, *Moonrise Over Hernandez, New Mexico*.

Water Memory felt alive. Two artists fully clad in dance costumes—Rose Simpson and Cara's brother-in-law Santi Romero—were immersed underwater in an aquatic Corn Dance. Rose floats in the foreground, extending an evergreen branch used in the dance ritual, its color enhanced by the blue-green water. Santi hovers above her, receding into the background. He's floating on his back, his arms raised as if he's imploring the gods to bless the maize. Though the shot was meticulously choreographed by Cara in a swimming pool, you could just as easily be looking at a river or even the ocean.

Tony summed it up, "This photograph impacted me as one of the most important pieces of Native American photography."

§

I began my drive back to Santa Fe with the intention of getting home in time to attend Indian Market. Then in its 93rd year in 2014,

with approximately a thousand Native artists displaying their work in over two hundred booths, it promised to be the biggest yet. The city estimates the event draws a hundred and fifty thousand people (some say higher). However, that year it had competition. A radical organization called "IFAM," the Indigenous Fine Art Market, threatened to steal its thunder. IFAM was fed up with the Indian Market's elitist organization. They felt there was too much emphasis on status and money and not enough on the art itself. Their plan was to open two days before Indian Market and hopefully siphon off some of their stardust.

I walked over to the Railyard District to check out the upstart fair. Dozens of booths were filled with work of inconsistent quality. I witnessed everything from serious realism to half-baked graffiti art. Though the work may not have been the best, the mood was celebratory. There was a stage with a long list of scheduled performers. That afternoon, I listened to a group of Indian rap musicians, called the Chief Rockers, as they shouted, "Santa Fe make some noise!" The show was a spectacle, as much performance art as music. A longhaired artist wearing a crazy hat stationed his easel near the stage and began painting on a large canvas. Swaying to the pulsing beat and machine gun lyrics, he got into a groove, sketching out an image of a thunderbird. Encouraged by the rappers, children rushed the stage and began break dancing, as the onlookers whooped it up and hollered their approval. I have no idea how much art was actually sold that day, but if the Indigenous Fine Art Market was judged on audience participation, high spirits, and fun, the event exceeded expectations.

The next morning, I got up bright and early and went to the Plaza to experience my first ever Indian Market. The night before, a panel of judges selected from Santa Fe's dealers, curators, and collectors, awarded blue ribbons in numerous categories, including ceramics, textiles, and jewelry. The stakes were high. Winning a blue ribbon assured an artist of strong Indian Market sales. It also provided ammunition for future sales at the artist's galleries. And of course there were the bragging rights amongst one's peers. Although the fair technically didn't open until eight on Saturday morning, serious collectors arrive while it's still dark to compete for the best work. The prizewinners often sell out their booths before the fair officially gets underway.

I strolled around the Plaza, shocked by the crowds and rabid buyers. Some of the art was nothing short of amazing. The Best of Show winner was a Navajo weaver named Lola Cody. She won for a Two Grey Hills rug, which measured a tremendous 8' x 13,' and took over two years to weave. Its geometric patterns of grays, browns, and blacks was a masterpiece of the weaver's art. What took it to the next level was how every fiber was imbued with the essence of the New Mexican landscape. Tourists clogged her booth, stunned by the majesty of her work. Cody was asking a hundred and ten thousand dollars for the treasure. So far, a buyer had not emerged.

I soon ran into Tony Abetya, wearing a bright red and blue baseball cap and oversize sunglasses; he radiated rock star. He was with his usual entourage of young American Indian painters. Only today, they all sported the same white tee shirt designed by Jaque Fragua, which read "Famous Indian Artist." Their shirts were riddled with bullet holes.

Each garment's intentionally tattered state was a reference to a recent incident involving the painter Mateo Romero. One evening, he was driving down Old Santa Fe Trail, when his pet Shih Tzu, Han Solo, relieved himself inside his SUV. Mateo pulled into a random driveway to clean out his car. Unknown to Mateo, the owner of the house spotted him, feared she was about to be robbed, and called the police. A patrol car showed up in a flash. Suspecting a burglary was in progress, one of the officers pointed his rifle at Mateo. Though Mateo tried to explain what he was doing, the officer was having none of it, barking out, "You'll get a chance to tell your story later." Eventually, it all got sorted out. But the absurd drama made the papers and gave the local art community a good laugh. Hence, Jaque Fragua's creative attempt at ironic humor.

Meanwhile, Tony introduced me to Mateo Romero. His booth held a wide selection of his recent paintings. Mateo utilized black and white photographs, depicting typical Indian iconography, and covered them with thick viscous paint. But he allowed just enough of the imagery to peek through the paint so it became the focus of the composition. Trying to have some fun, I asked him, "So who's a better artist, you or your brother Diego?"

Not missing a beat, Mateo said, "The question you should be asking is who's better looking? And I think we both know the answer to that."

The high point of the fair was meeting the Navajo jewelry designer Jesse Monongya. His father was Preston Monongya, who along with Charles Loloma, Ambrose Roanhorse, and Kenneth Begay, formed the foundation of modern American Indian jewelry. For months, I had been seeing two-page advertising spreads for Jesse's work in *Western Art & Architecture*. He creates buckles, bracelets, and rings out of gold (most Native artisans work exclusively in silver) with intricate inlays of precious stones. One of his rings, which received a first-place ribbon at Indian Market, was priced at a whopping twelve thousand dollars.

I introduced myself and was shocked by how open Jesse was—and how outspoken. His work was so good he could afford to be cocky. I asked him about Charles Loloma, since I was under the impression that he was universally respected. "Are you a big Loloma fan?"

"No," he said abruptly. "I knew Loloma. He would use a few good stones and then finish the design with less expensive materials like ironwood. I use the best gemstones and Mediterranean coral I can find—throughout the entire piece." I was taken aback. I had never heard anyone criticize Charles Loloma before. It almost felt sacrilegious.

"What do you think of Fritz Scholder—would you rank him as the greatest American Indian painter?" I asked, feeling like I already knew the answer.

Jesse seemed to like that question. "He's barely an Indian."

"Isn't he part Luseno?"

"Maybe his big toe," Jesse said, laughing.

So much for great revelations in the Native American art world.

I strolled past a booth whose centerpiece was a kachina doll made from multi-color Legos. Its teenage creator, named Tulane John, took first place in his age group for sculpture. I then ran into Marvin Slim and his wife Luana. They had a booth in a prime location, right off the Plaza. Browsers stood two deep in his space. I said to Marvin, "Your display looks great."

"Yeah, we're doing really well," smiled the always good-humored artist. "I brought a lot of rings and they're selling. People don't realize artists spend an entire year creating work just for Indian Market. Everything's riding on this weekend. This show represents a year's worth of income

for many of these guys." I hadn't realized there was that kind of pressure on the artists. Twelve months is a long time to work for a risky two-day payoff.

I spotted Billy Schenck. Prior to the show, he swore up and down he wasn't going to buy anything this year. But as he walked around, and saw all the goodies, his hopeless collector instincts kicked in, "You know Richard, this time of year I can always use a good kachina." I wondered if he had his eye on the Legos version.

...

19

THE LAST INDIAN MARKET

It was now late summer and the heat was on, in more ways than one. I walked into Counter Culture for breakfast and saw a sign posted at the register: "The Green Chile is Muy Caliente Today." Despite the warning I ordered their breakfast burrito, which was loaded with Hatch chile, and took a seat outside. I watched in amazement as a large Western Tiger Swallowtail butterfly floated by. Its yellow wings, outlined in black lines like stained glass, were offset by iridescent spots of rust and blue. If there was a more striking butterfly in America, I wanted to see it.

After "desayuno," I took a drive to Chimayo. As I passed through Espanola, I saw another sign, painted on a large trailer, which read, "We Buy Antlers." I thought, This is definitely worth a look. I made an abrupt U-turn and pulled into a strip mall parking lot. I was greeted by a man whose business card announced he was Trinity Walker, "Antler Buyer."

I asked Trinity, "So how much do you pay for antlers?"

Trinity appeared to be in his mid-thirties and had that grizzled outdoorsman look, complete with a knife in a sheath hanging from his rawhide belt. "It depends. I pay the most for moose, then elk, then deer. It also depends on how fresh the antlers are—the fresher the better. It's all about color."

He pointed to the knob at the end of an antler that connects it to the creature's head, "See this—dried blood. That's a sign the deer recently lost it."

"So what are you paying?"

Trinity scratched his chin, "Six dollars a pound for fresh deer, nine dollars for elk, and eleven for moose."

Then he grabbed an antler—I thought it was moose—and handed it to me, "Put that on the scale."

I did as he instructed and was surprised to see it weighed seven pounds. Trinity spoke, "That antler is worth seventy-seven dollars. Someone who's really good at tramping around the woods and knows what he's looking for can easily make four, five hundred dollars in an afternoon."

"That's amazing. I had no idea antlers were so lucrative."

"You'd be surprised. We ship a lot of them overseas to Asia. Here in America, we have several manufacturers who make lamps, chandeliers, and coat racks out of them. People buy them for their rustic cabins in Montana and Wyoming. They really look great in that environment."

I thanked Trinity for his introduction to the antler business and resumed my short drive to Chimayo. I wanted to visit the Santuario Chimayo, built in 1816. Once I arrived, I spent thirty minutes basking in the chapel's wonderful frescoes, painted in a Spanish folk art style. To the left was an adjoining room with a ceiling so low that you had to stoop your head. There was a hole chipped out of the concrete floor, the size of a dinner plate, filled with dirt which had been blessed by a priest. Several visitors held Ziploc bags, hurriedly spooning holy dirt inside. The dirt was said to possess healing powers. It could be sprinkled on those seeking a miraculous cure (or even ingested). A third room was lined with a long row of discarded aluminum crutches. The configuration resembled an art gallery installation, while offering a striking testament to those who had been healed.

The religious overtones and artful staging brought to mind Cara Romero's recent piece, *The Last Indian Market*. It was conceived as a parody of Leonardo da Vinci's mural, *The Last Supper*. As every student of art history knows, da Vinci's painting portrays Jesus Christ surrounded by the twelve apostles, on the night before his crucifixion. During the meal, Christ proclaimed, "One of you will betray me." The next day, it came to pass.

Cara Romero's version is far more benign. She recruited thirteen Santa Fe male and female painters, jewelry makers, and ceramicists for the project. Cara requested that they wear dress clothes and meet her at an upscale restaurant. She then posed them at a long table, with six

"disciples" on the left—her husband Diego played Judas—and another group of six on the right. The "Jesus figure" ruled the middle, resplendent in a white suit, his head enveloped inside an actual buffalo head. A humble loaf of bread, similar to those baked in a pueblo horno (oven) was placed before him. The table was covered with an elegant black and white diamond tablecloth, with carefully arranged pears, apples, grapes, and pomegranates. Each person's hand gestures and facial expressions imitated those of the corresponding disciples in da Vinci's *The Last Supper*.

Though Cara's picture has a playful quality to it, the questions it raises are intriguing. Does she see Native American artists as religious figures? Do certain individuals occasionally undermine one another's careers? Or is it simply about honoring members of the Santa Fe creative community? All of this is left to the viewer to decide.

A few days later, I invited Cara and Diego to lunch at Dr. Field Good's Kitchen. The restaurant was only two years old, but it had already made tremendous inroads into the Santa Fe dining scene. Josh Gerwin, its chef and owner, put together an impressive menu of locally-sourced comfort food. I ordered a margarita pizza. It arrived hot from the wood-burning oven. Its chewy paper-thin crust was covered in thick slices of ripened heirloom tomatoes, puddles of melted white mozzarella, a dash of sea salt and olive oil, and topped with a few arugula shavings. These simple but pure ingredients blended beautifully together, transforming each bite into sheer bliss. I knew if I ever moved, I'd miss Santa Fe's green chile, but I just might miss Dr. Field Goods's margarita pizza even more.

As I handed a slice to Cara, she explained that her art was concerned with how Native Americans are not always represented authentically, and that she hoped to address some of those inaccuracies. We never got into specifics and I sensed she preferred to let her work speak for itself. Cara was thirty-nine (then) and blessed with striking eyes. She saw herself as a social activist with a more subtle approach than Fritz Scholder. His genius was getting non-Natives to view America's indigenous people as regular human beings—no different than they were. He painted American Indians living typical American lives.

The majority of Native artists who followed Scholder and T.C. Cannon practiced a kinder and gentler art. Gone, for the most part, was

the anger. A different type of passion emerged. Much of today's American Indian art basks in cultural romanticism. Not that this is necessarily a bad thing. Perhaps the work lacks the edge and poignancy of the AIM-influenced art of the 1970s. But it makes up for it with a heartfelt desire to please its audience.

If you walk around Santa Fe's Canyon Road and downtown Plaza, and have the ability to filter out lesser quality work, you will come across a fair amount of attractive Native American art. Though it is often authored by a little-known artist, and its subject matter breaks no new ground, it still resonates. If you extend your search to the rest of New Mexico, and then go beyond its borders to Arizona, Colorado, and Utah, you'll find even more of this. Not all American Indian art is meant to change art history. Much of it simply strives to give an honest voice to its creator.

The chief difference between mainstream contemporary artists and Native American artists is that the latter group rarely cites fame and fortune as the arbiter of success. With contemporary artists, it used to be all about careerism. You hadn't really made it unless you exhibited at a "top twenty" New York gallery, had your show reviewed in Artforum, and were selected for a Whitney Biennial. In today's investment-driven art world, it's all about having a strong enough secondary market to appear at a Sotheby's or Christie's auction. It's not that Native American painters don't want recognition or their work to appreciate in value. Of course they do. But there's a greater emphasis on staying true to your culture. Even the most ambitious painters, including Tony Abeyta, somehow always return to incorporating American Indian iconography in their work—even if it only represents one aspect of their production. The Native American perception of having a fulfilling career is based on its own set of expectations.

Fritz Scholder's problem was that he wanted it both ways. He was obsessed with status and recognition. His frustration was that the New York art market wouldn't accept his non-American Indian imagery—and he refused to accept the reason why. To be blunt, in my opinion, these paintings weren't very good. His late figurative work, which was heavily influenced by the Northern Californian painter Nathan Oliveira, was a misguided attempt to be seen as a "serious" contemporary artist. Scholder

became an imitator rather than an innovator. Fortunately, art history ultimately judges a painter based on his high-water mark. Fritz Scholder will be remembered for the paintings that he hit out of the park, between 1969–1974.

What's remarkable about Cara Romero is that, unlike Scholder, she may be able to have it both ways. With the struggle of what it means to be a modern Indian artist largely in the rearview mirror, she has moved on to the next phase. She's able to have fun with the viewer, gently provoking him. But there's also a subliminal message in her iconography of unwavering Native pride. Cara Romero's photographs function like paintings, given their large-scale format, sweeping colors, and thoughtful compositions. While no one can predict the future of art history, her work seems destined to escape being ghettoized as Native American art—and seen simply as art. Someday, you will likely hear her name mentioned with the same group of internationally acclaimed photographers who are thought of as painters, specifically Andreas Gursky and Jeff Wall.

Should that happen, Cara will have fulfilled Fritz Scholder's "prediction" of the shape of things to come when he painted *Indian with Beer Can*, during Pop's glory days. The painting was so profound that it should have catapulted Scholder into the Leo Castelli Gallery, to hang alongside Warhol, Rosenquist, and Lichtenstein. But that was then. The good news is that art history is always being re-evaluated. All it would take is one major contemporary art dealer with the moxie and the vision to mount a full-blown Fritz Scholder show. The opportunity is there for the taking. And it could happen when you least expect it.

20

AN AMERICAN INDIAN ART RENAISSANCE

Tony Abeyta was on "landscape duty."

I walked into his studio and found him hard at work, fulfilling various commissions. Fortunately, Tony paints relatively fast. He gets into a rhythm, the brushstrokes flow, and the forms magically appear. Running rivers recede into the distance. Rolling hills fade into the horizon. Skies clogged with overlapping clouds hover above. And the assorted processional figures, adobe houses, and high desert vegetation come to life.

"What's up, Polsky?" Tony cried out.

"I just thought I'd swing by and see what you're up to."

"Everything is super-fantastic," Tony said, smiling. That day, he had on a white V-Neck tee-shirt, jeans, and a light gray watchman's cap precariously balanced on top of his head. You rarely see Tony wearing his own magnificent jewelry. Instead, he wore a short necklace created by a friend, with tiny metal charms dangling in the center.

Tony went back to work, freely conversing with me while he painted. He was totally at ease. Many artists require solitude while they paint. But not Tony. If anything, the steady interruption of visitors, phone calls, and text messages seem to energize his work.

While I watched him flick a brushstroke onto a canvas, I said, "You know, I've been reading this Tony Hillerman book about a bunch of skinwalkers."

Tony put down his brush, turned to me and yelled, "I don't want to hear about skinwalkers when I paint."

At first, I thought he was putting me on. But the look on his face

told me he meant business. Skinwalkers are Navajo witches. Legend has it they were shapeshifters who could turn themselves into coyotes, and then back into humans, when it suited their purpose. They had bad ju-ju, which I suppose is what freaked Tony out. Many Navajos believe skinwalkers still exist.

I quickly changed the subject with Tony. He mentioned he was planning to fly to Berkeley to continue his search for a place to live part-time. As luck would have it, I was also planning to be in the Bay Area.

When Tony heard that, he said, "I know you're friends with Mel Ramos. Since his studio is in Oakland, and I've always wanted to own one of his prints, is there any chance of you bringing me over there?"

Mel Ramos was one of the original Pop artists. He was known for his lavishly painted female nudes, which he often juxtaposed with consumer products, such as a Hunt's ketchup bottle, a Velveeta cheese box, or a Coca-Cola bottle. During the 1960s, Mel showed with the renowned Leo Castelli Gallery. After that, he continued to paint while teaching at San Jose State. I got to know Mel during the 1980s, when a gallery I worked for commissioned him to do a series of paintings. Over the years, I'd run into him at various art openings, and he always went out of his way to be friendly to me.

"Sure, I'll give Mel a call and see if he's available," I said.

When I spoke with Mel, he was kind enough to invite us over. We stopped by and were welcomed into his comfortable home in the Oakland hills. The walls of the living room were hung with paintings that Mel acquired over the years—most by trade. There were two paintings by Wayne Thiebaud. Ironically, Mel Ramos and Fritz Scholder were Thiebaud's most famous students. When we went downstairs to Mel's studio, I was immediately struck by a canvas in progress of a superhero. Right before Mel painted his breakthrough nudes, he painted a series of comic book superheroes, which included Superman, Batman, and Wonder Woman. Now, he was reprising the series.

Tony was like the proverbial kid in a candy store. Although he was an artist, he was also a collector at heart. He quickly homed in on a recent print of the Phantom that was based on a 1960s painting. The somewhat obscure character wore a purple costume which contrasted beautifully

against a taupe background. The large color lithograph was in the three thousand dollar price range.

Tony examined it for a few minutes and said, "I'll take it."

Mel smiled as his daughter Rochelle, who was also his office manager, wrote up an invoice. Tony handed her a check and just like that he was the proud owner of a Mel Ramos.

After some artist shoptalk, we departed. On our way out, Tony invited Mel to visit his studio the next time he came to Santa Fe.

Watching Tony enjoy himself at Mel's studio was a reminder of why he is so successful. It comes down to his willingness to see beyond his own work and the Native American art scene. Tony maintains a curiosity about the greater art world. He wants to learn all he can about the contemporary art world, including the market. Tony follows the auctions at Sotheby's and Christie's. He has a general understanding of the price structure of every major artist. He knows where they show, is familiar with their imagery, and understands where they rank in art history.

Virtually all of the Native artists whom I've met in the Southwest don't follow the contemporary art world. They are too busy making a living. There's nothing wrong with an artist staying within his comfort zone. Most of the artists have good lives. They have families and friends, live off their work, and find a way to keep doing what they enjoy doing. But if Native American painting is to get to the next level—which means mainstream recognition—something has to change. And it isn't going to be the artists.

Instead, the issue just might take care of itself. In 2020, the art world experienced a seismic shift. After years of talk, museum curators finally began to act on the premise that their institutions didn't accurately tell the story of twentieth-century art. The collections were filled with paintings primarily by White male artists. This was particularly true of Post-War painting. There was a decided lack of women represented and an even more pronounced underrepresentation of artists of color. Perhaps the Black Lives Matter movement brought everything to a head. Or maybe the shifting demographics of America had finally caught up with the art world. Whatever it was, change was in the air.

In 2020, the Metropolitan Museum of Art appointed Patricia

Marroquin Norby as its first curator of Native American art. Whatever the outcome of her tenure, it now seems certain that Native art will be "in play." In the same spirit of how Black artists are becoming highly sought after at auction, it feels inevitable that Native American artists will be next. Museums are going to have to find a way to blend in indigenous art. This will inspire collectors to follow their lead and start buying the top Native artists. Once that happens—and there is strong evidence that it's already happening—Tony Abeyta and his colleagues will experience a renaissance in their careers.

AFTERWORD

In December 2019, just two months before the Covid pandemic, I was in Albuquerque with my wife Kimberly. We decided to splurge and stay at the new Hotel Chaco, whose contemporary design was inspired by the ancient Chaco Canyon cliff dwellings. Since it was located only a short walk from Old Town, I headed over to the Plaza to check out the American Indian jewelry. The Plaza featured perhaps two dozen artisans who displayed their wares outdoors on blankets, similar to the action along the Palace of the Governors in Santa Fe.

There was the usual assortment of bracelets and necklaces; nice but nothing out of the ordinary. Then I came across an artist showing small paintings. His name was Bennard Dallasvuyaoma. A placard referred to his work as "Pima/Hopi Art." The pictures were a hybrid of traditional imagery and modern style. There was one painting, in particular, which stood out. It was a 12" x 9" canvas which depicted a buffalo. The so-called "Lord of the Great Plains" appeared as a ghost image, superimposed on a tall canyon wall. The apparition of the bison was crisply executed in raw sienna paint; there wasn't a single wasted brushstroke. What brought the painting to life were the vertical slabs of cobalt blue and deep turquoise which defined the canyon. Bennard had created a powerful picture that spoke of traditional American Indian life, informed by Post-War American painting.

"That's an amazing picture," I said, pointing at it.

Bennard smiled, "Thank you—I'm glad you're enjoying it."

"Tell me about your work."

"I'm a retired engineer who now paints full-time," Bennard said. "I also make jewelry." He handed me a necklace with elaborate inlay work which incorporated a tasty variety of stones.

"That's a nice piece," I said. "I can see the Loloma influence."

"He was my uncle," Bennard said, grinning.

I shook my head in amazement, and asked, "How much is the painting?

"A hundred and twenty dollars."

Taken aback by its affordability, I smiled, "Do you take cash?"

"Cash works," he said.

Thrilled by my purchase, I walked back to the Hotel Chaco to share my new find with Kimberly. When I pulled it out of a pale green plastic bag, her eyes grew wide, "I really like it. Where did you get that?"

"I just bought it directly from the artist at the Plaza."

I placed the canvas on the dresser, leaned it against the wall, and stood back to admire it. The picture simply glowed. It was a reminder that for every Tony Abeyta, there was a Bennard Dallasvuyaoma. His powerful work gave me the same emotional jolt as the Tony Abeyta landscape I lived with. Tony is a once-in-a-generation talent. But in his own way, so is Bennard. He may never find Tony's fame and notoriety. Yet, he had just as much to say as an artist.

Both are "native geniuses."

SOURCES

The following books provided inspired reading about Native American art of the Southwest and related topics:

Baer, Joshua, *Collecting the Navajo Child's Blanket*, Santa Fe: Morning Star Gallery, 1986.

Baer, Joshua, *The Last Blankets*, Santa Fe: Joshua Baer & Company, 1998.

Berkowitz, Paul D., *The Case of the Indian Trader*, Albuquerque: University of New Mexico Press, 2011.

Berlant, Tony, and Brody, J.J., *Mimbres Pottery Ancient Art of the American Southwest*, New York: Hudson Hill Press, 1983.

Booker, Margaret Moore, *Southwest Art Defined*, Tucson: Rio Nuevo Publishers, 2013.

Breeskin, Adelyn D., *Scholder/Indians*, Flagstaff: Northland Press, 1972.

Brody, J.J., *Indian Painters &White Patrons*, Albuquerque: University of New Mexico Press, 1971.

_____. J.J., *Pueblo Indian Painting*, Santa Fe: School of American Indian Research Press, 1997.

Campbell, Suzan, *Taos Artists and Their Patrons 1898–1950*, University of Notre Dame, South Bend, Indiana: Snite Art Museum, 1999.

Frederick, Joan, *T.C. Cannon: He Stood in the Sun*, Flagstaff: Northland Publishing, 1995.

Fried, Stephen, *Appetite for America: Fred Harvey and the Business of Civilizing the Wild West—One Meal at a Time*, New York: Bantam Books, 2011.

Gibson, Daniel, and Leaken, Kitty, *Kevin Red Star*, Layton, Utah: Gibbs Smith, 2014.

Highwater, Jamake, *The Sweet Grass Lives On*, New York: Lippincott & Crowell, 1980.

Lukavic, John P., *Super Indian Fritz Scholder 1967–1980*, Denver: Denver Art Museum, 2015.

Monthan, Guy and Doris, *Art and Indian Individualists*, Flagstaff: Northland Press, 1975.

Muller, John, "A Gift From The Wind," *New Mexico Magazine*, August, 2015.

Rudnick, Lois P., and Wilson-Powell, MaLin, *Mabel Dodge Luhan & Company*, Santa Fe: Museum of New Mexico Press, 2016.

Sims, Lowery Stokes, *Fritz Scholder Indian/Not Indian*, Smithsonian Institution, New York: Prestel, 2008.

Struever, Martha Hopkins, *Loloma*, Santa Fe: Wheelwright Museum of the American Indian, 2005.

Taylor, Joshua C., *Fritz Scholder*, New York: Rizzoli, 1982.

Tisdale, Shelby J., *Fine Indian Jewelry of the Southwest (Millicent Rogers Collection)*, Santa Fe: Museum of New Mexico Press, 2007.

www.ingramcontent.com/pod-product-compliance
Lightning Source LLC
Chambersburg PA
CBHW011800170526
45163CB00010B/3127